The
Ring
of
Time

Ring out the old,
ring in the new . . .
Ring out the false,
ring in the true.

Alfred, Lord Tennyson

The Ring of Time

The Story of the British Columbia Provincial Museum

Written by
Peter Corley-Smith

Art & Design by
Rennie Knowlton

British Columbia
Provincial Museum
Special Publication No. 8

BC Ministry of Provincial Secretary
and Government Services
PROVINCIAL SECRETARY

CANADIAN CATALOGUING IN
PUBLICATION DATA

Corley-Smith, Peter, 1923-
The Ring of Time

(British Columbia Provincial
Museum Special Publication.
ISSN 0707-1728; no. 8)

On cover: The Story of the
British Columbia Provincial Museum
ISBN 0-7718-8428-1

1. British Columbia Provincial
Museum — History
I. British Columbia Provincial
Museum
II. Title
III. Title: The Story of the British
Columbia Provincial Museum
IV. Series

AM 101.V52C67 1984
069′.09711 C84-092150-0

Published by
The British Columbia Provincial
Museum, Victoria, B.C.

First Printing.................1985

This book was produced by
Bill Barkley
Peter Corley-Smith
Harold Hosford
and
Rennie Knowlton

and published with
support from
The Friends of the
Provincial Museum

Dedication

This book is dedicated to our "friends".

The Friends of the British Columbia Provincial Museum are a very special group of people. This non-profit society is without doubt one of the reasons for this museum's many successes.

The financial and moral support they provide motivates our talented and creative staff to continue to strive for excellence.

This book is a tribute to our many "Friends" for their many good deeds.

Thank you.

Contents

Introduction

This book tells the story of the British Columbia Provincial Museum. It is mostly a story of the Museum since its move to its present premises in 1968. However, the original petition signed by a group of prominent British Columbia citizens explains with clarity why the Museum was formed and what it was to do. This document was presented to the Queen's representative in 1886. The petition is quoted below:

To His Honour
The Lieutenant Governor in Council
re: A Provincial Museum

May it please Your Honour

It has long been felt desirable that a Provincial Museum should be established in order to preserve specimens of the natural products and Indian Antiquities and Manufactures of the Province and to classify and exhibit the same for the information of the public.

It is a source of general regret that objects connected with the ethnology of the country are being yearly taken away in great numbers to the enrichment of other museums and private collections while no adequate means are provided for their retention in the province. Limited as such articles are in quantity their loss is frequently irreparable, and, when once removed from the locality of their production, their scientific value and utility to the country are greatly lessened.

There is no doubt that the recent opening up of British Columbia by railway enterprise will stimulate the development of her mineral and other natural resources; hence, a museum where classified specimens of ores, etc. may be examined, will prove of practical benefit to the Province at large. It is an acknowledged fact that the Natural History of the country is by no means as yet perfectly understood, and it is trusted that if a centre for investigation be afforded, the interests of that science will be advanced, and the attention and cooperation of naturalists of other countries will be gained.

There are at present in the Province many gentlemen interested in furthering this scheme who have signified their readiness to assist to the best of their powers.

At a meeting, held for the purpose of considering this subject, upon Thursday, Jan. 14th it was resolved to memorialize Your Honour in Council, praying that such steps may be taken by the Government towards establishing the proposed Institution as may be considered requisite.

And your Petitioners, as in duty bound, will ever pray.

The message from the petition was that an institution was necessary in British Columbia to collect, preserve and study objects and specimens, and to inform the public about the natural specimens and man-made artifacts under its stewardship. The Museum has continued to satisfy that mandate from its beginnings.

In recent years the Museum has gained increasing recognition for the excellence and creativity of its exhibitry. Praise has been heaped on the institution from local and international sources. Some of the stories from behind the scenes are told in the following pages. As with any undertaking of this magnitude, there are happy events and sad events leading to these accomplishments.

Yet the reasons why the staff of this museum have become so successful are not obvious to those who were involved. When the move was made into the new buildings in 1968-69, there were few staff and a small exhibits budget, so the easy availability of resources was not a reason for these developments. The only answer seems to be the people themselves. The staff of the Museum were energetic and dedicated to their jobs. This fact, combined with the move into the new facilities, stimulated their creativity. The problems of financial resources were overcome with the help of a fund-raising group developed for that purpose, the Friends of the British Columbia Provincial Museum. An abundance of federal employment opportunity grants was available to hire staff. Those who were here at the time liken the scene to a "three-ring circus". In every corner of the buildings people were excitedly pursuing their own particular contributions to the renewed museum.

Out of public view, other things were going on. Collections were being enlarged and sorted. The curatorial staff were persuing areas of research relating to their particular collections and expertise. The specialized staff of conservators who care for the collections were making major breakthroughs in preserving our precious objects. As the public programs of exhibitry, publica-

The Museum has continued to satisfy that mandate from its beginnings

2

tions, and school and group services were receiving acclaim from visitors, students and teachers, the research and curatorial staff were receiving recognition from the musum and scientific community. Thus the Museum began to take its place as a leading light in museums, not just in Canada, but within a broader world context.

This book is an attempt to capture the excitement of what has gone on in the Museum in the past and is continuing in the present. The stories presented here are just glimpses from people's memories and written records but the essence of what the British Columbia Provincial Museum was, is, and will be in the future, is contained in them.

In concluding, the reader should understand that this book is not meant to be a guide, nor a definitive history of the Museum; it is intended to provide the reader with an insight into the "personality" of the BCPM, if an institution can be said to have a personality. The following pages will help you to explore that personality in more depth.

Friends of the British Columbia Provincial Museum

The move of the Museum to its new premises in 1968-69 resulted in considerable change to the Museum's perception of itself as an institution and to the public's perception of the Museum. Shortly after the new buildings were occupied, a group of volunteers was formed to look after the school groups. This group became the Docents Association. The Director of the Museum at the time, Dr. G. Clifford Carl, recognized the need for another more broadly based support group for the Museum. He discussed this idea with Kathleen Craig, who was chairperson of the Docents Association; she in turn proceeded to arrange a meeting of the people from the community.

A first meeting was arranged with representatives of nine different interest groups. The result of this meeting was the incorporation of the Friends of the British Columbia Provincial

Museum as a non-profit society on July 20, 1970. The Society's purposes are as follows:

1. To promote the interests of the British Columbia Provincial Museum.

2. To promote understanding, communication and cooperation between the people of British Columbia and the Provincial Museum.

3. To provide interested persons and organizations with opportunities to share in the development of the Museum and in the benefits which it may offer.

4. To assist the Museum in publicizing its activities, its needs, and its offerings.

5. To bring to the assistance of the Museum on a voluntary basis the talents and abilities of the public at large.

6. To undertake such other activities which from time to time may be deemed appropriate.

The Friends group is made up of two types of membership: individual members and affiliate group members. Individual members are people who wish to express their support for the Museum and receive information about and benefit from Museum programs. Affiliate groups are organizations which have a wide range of interests but in some way their activities relate to the purposes of the Museum. Examples of affiliate groups are the Victoria Natural History Society, the Victoria Camera Club and the British Columbia Historical Society, to mention just a few.

Once formed, the Friends came quickly to the support of the Museum in various important ways

Once formed, the Friends came quickly to the support of the Museum in various important ways. Their first major activity was to raise money to build the Modern History Gallery. In co-operation with the staff, they secured funding from a variety of businesses, community groups and provincial organizations.

On November 17, 1970, the Friends took over the operation of the Museum Gift Shop. This retail sales outlet became a thriving business under the direction of the Friends. It is staffed by two paid employees and a dedicated group of about 60 volunteers. The profits from the Gift Shop operation provide the money for special projects funded by the Friends for the Museum. These, and funds raised in other ways, provide the special touches to this institution that could not be funded from the regular operating

budget. Friends money has provided for a vast array of projects from funding the book you are reading to purchasing sophisticated and complex electronic equipment to allow a scientist to analyze 10,000-year-old deposits of blood on stone implements.

The Friends organization has continued through the years to be an outstanding success story. Capable and enthusiastic people seem to be attracted to this group and it continues from one success to another. Indeed, the success of this museum has a good deal to do with the Friends continued financial and moral support.

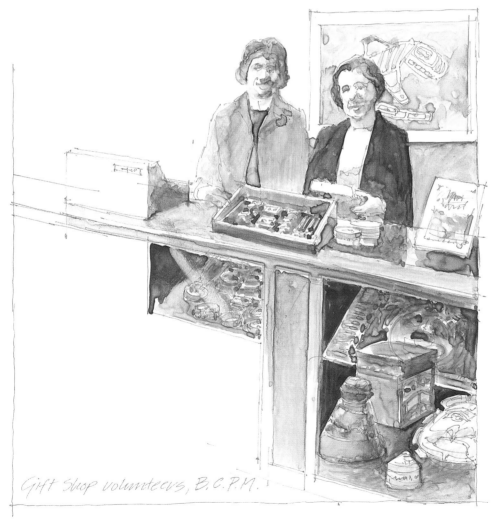

Gift Shop volunteers, B.C.P.M.

The Friends organization has continued through the years to be an outstanding success story

The
Ring
of
Time

The Ring of Time

The Illusion of Reality

In the summer of 1978, a young tour guide was conducting her first group through the Modern History Gallery of the British Columbia Provincial Museum. For the previous five weeks she had been intensively trained. Curators and educators had lectured to her; she had been bombarded with facts and philosophies, classifications and cultures. She had done practice tours during which she had been asked any number of 'typical' questions a visitor might ask. Now, nervously, she was trying to remember all the gems of wisdom she was supposed to impart to visitors.

Standing in front of the Cornish water-wheel, she had just finished describing the Barkerville gold rush of the 1860s. Her description had gone well, she thought; she began to feel more confident — confident enough to invite questions. A tourist in the little semicircle of her group looked up at the revolving wheel, with water dripping off its blades, and asked, "Is that real water?"

"Is that real water?"

Comprehensive as her training had been, nothing had prepared her to answer this question. She was speechless. Yet in fact, this question was a singular compliment to the curators and designers of the gallery. Visitors could no longer distinguish between illusion and reality.

A New Home

Before 1968, British Columbia's Provincial Museum of Natural History and Anthropology had no dedicated home. It occupied what space happened to be available in and around the Legislative Buildings in Victoria. After 1968, the Museum did have a permanent home: the one that houses it now.

The provincial government had decided earlier in the decade that the major project to celebrate the 1967 centenary of Confederation in Canada would be a new museum complex. The planned cost of the new complex was $5 million, of which half would be provided by the federal government. As is so often the case, both projected costs and deadlines had to be extended. In the end, the new complex, called Heritage Court, cost $10 million and was completed a year after the centennial date, opening in August, 1968. Situated across the street from the Legislative

Buildings, Heritage Court included a carillon tower, an archives building, a curatorial tower and an exhibits building. At the same time, the Museum Act was amended to include modern history as well as natural history and anthropology in the Museum's mandate and the Museum became the British Columbia Provincial Museum.

The 12 people on staff were faced with awesome tasks; one was the 100,000 square feet (30,500 m²) of exhibit space to be filled. However, reinforced with a new chief designer and a new modern history curator, they set about producing a comprehensive plan for the new galleries.

Questions, Questions, Questions

There are three principal participants: the curator, the designer and the conservator.

The evolution of a new museum exhibit gallery is a complex process. There are three principal participants: the curator, the designer and the conservator, each with his or her own imperatives. The curator is wholly dedicated to historical or scientific accuracy. The designer is engrossed with a mixture of theatre and effective communication. The conservator worries about protecting artifacts or specimens from deterioration. Somehow, all these imperatives have to be resolved into a successful exhibit. Compromises are necessary, but they can never be easy ones and the tensions which exist during these negotiations are what makes a great exhibit.

Stories Within Stories

The first decision this team had to make concerned an overall theme — what is known in museum circles as a story line — to integrate the proposed galleries. The decision, when it came, was to adopt the concept of a *ring of time*. Visitors to the galleries would embark on a voyage through time, starting with the present, going back through history to the dawn of man and then returning, through the re-creations of archaeology and the history of the native peoples, to the present.

'The Ring' Emerges

The concept of a *ring of time* provided a framework and, even though the original circle had to be modified into a figure eight, the concept still worked. The next and obvious decision was what to start with: natural history, anthropology or modern history? The museum had extensive natural history and ethnology collections, but both presented problems of conservation and preparation for display. So, because modern history would be appropriate for the celebration of a centennial, and because the modern history collections could be assembled and prepared more readily, the first permanent gallery in the new complex was the Modern History Gallery.

The decisions reached so far were important, but they were also theoretical. Now the practicalities had to be faced. The ambition of the planners was to create a gallery that would convey the history of this province so effectively that it would also attract international recognition. The budget for the Museum at that time was $20,000. Somehow, a lot more money would have to be found. More importantly, perhaps, the question of display techniques had to be resolved.

Logically, the decision about what kind of a gallery it would be came first; then the amount of money required to create that gallery could be estimated and the fund raising, whether through political or commercial persuasion, could begin.

But there was the question of how to deal with a subject as vast as the modern history of this province in one gallery. Even a brief summary of this history indicates its richness and diversity, the problems of selectivity.

Visitors to the galleries would embark on a voyage through time.

Unlimited Richness: A Matter of Choice

During the last half of the eighteenth century, and the first half of the nineteenth, the area we now know as British Columbia was like an orphan: everybody felt that they ought to adopt it but nobody wanted to pay for its upkeep. The early explorers, the sea captains, came to the coast intent on expanding trade and gaining personal prestige by discovery. First on the scene were the Russians and the Spanish, but they over-extended themselves and had to withdraw, leaving the field open to the British and finally the

Sea Otter (Enhydra lutris)

Americans.

In far off London, the government shied at the expense of administering this remote territory, whose only asset in their eyes was the Sea Otter which, by the 1820s, had been harvested almost to the point of extinction. For the rest, there were the forests, too remote to be harvested economically, and a forbidding land of ice-girt mountains that stretched, range after range, in the path of commerce.

But, in the 1850s, just as the California gold rush was fizzling out, gold was discovered on the sand-bars of Fraser's River

But, in the 1850s, just as the California gold rush was fizzling out, gold was discovered on the sand-bars of Fraser's River and the territory now called British Columbia took on a new lustre — particularly in the eyes of our neighbours to the south.

This is not intended to be a history of British Columbia; thus it is sufficient to say here that a boundary between Canada and the United States was established on the 49th parallel, and the Hudson's Bay Company succeeded in pre-empting the southern tip of Vancouver Island, which is below the 49th parallel, by building a fort in what was to become Victoria.

And James Douglas, Chief Factor of the Hudson's Bay Company, to whom much credit has been given for preserving western Canada from American encroachment, lived long enough to become *Sir* James, Governor of the colony of Vancouver Island, and finally of the newly constituted colony of British Columbia.

Once the borders in the west had been firmly established and the influx of miners and prospectors had stabilized, the colony began to develop its resources. Lumber, minerals, fish and farm-land were here, some in abundance, but none was easy to exploit because of the difficulties of transportation. All the resources of technology were needed to develop them. Horsepower gave way to steampower, the stage-coach to the railway, the sailing ship to the steamer. Gradually at first, but with increasing urgency, the relative simplicity of steam mechanism was replaced by the sophistication of the internal combustion engine, automation and electronics. Meanwhile, the old order of farmer, miner, logger and fisherman was being overlaid by a much more complex social fabric.

In short, the curators and designers, when they began to plan a modern history gallery for the new museum building, were faced with an almost unlimited richness of possibilities from which to choose how to approach the subject.

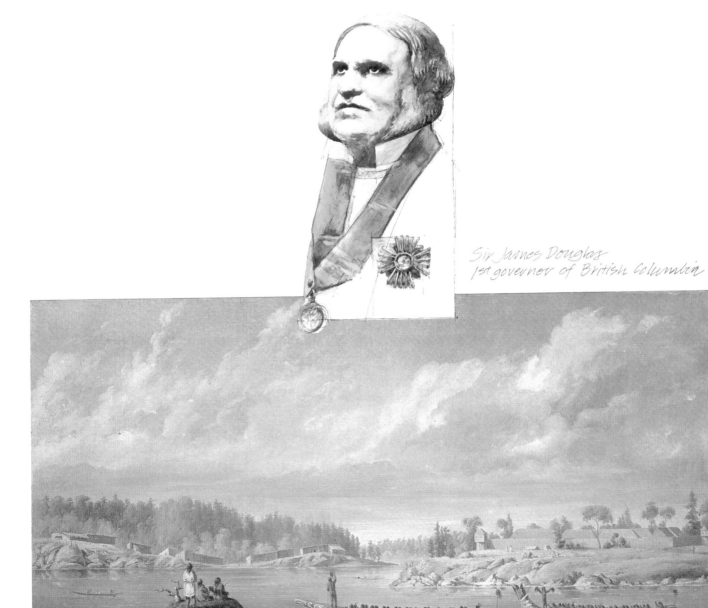

Sir James Douglas
1st governor of British Columbia

Return of a War Party · Paul Kane Courtesy of the Royal Ontario Museum

Answers, Answers, Answers

They had already agreed that, instead of displaying their collections of artifacts in isolation, they would simulate original environments and display the artifacts so that the viewer could see them as they once were. This would create a mood or atmosphere of the past — an atmosphere to be enhanced by sound and smell as well as sight. There were to be some interesting problems in this connection later.

The curator began by defining the period 'modern' history would embrace. He pegged the beginning to the fur trade and exploration era of the 1740s — approximately the time of first contact between white men and native peoples.

With the period defined, it was now necessary to find a way of presenting history; to decide which is most important: social history, industrial history, economic history. If you combine all the aspects of history the relationships between them may not be apparent; worse, the result is likely to be confusing. To produce an approach that is accessible to everyone, the curator has to have some sort of organization to his interpretation. In this case, the curator decided that economic changes came first, and other changes followed. This might be disputed by other historians, but it provided a structure on which to build a coherent exhibit.

Now came the elements of that structure, the selections. What buildings and artifacts would reflect the economic changes and their impact on the social and political life of the province? The curator began with a break-down into the following categories: Metropolis (1920s to 1970s); Urbanization & Industrialization (1870s to 1920s); Gold Rush Era (1840s to 1890s); and Fur Trade & Exploration (1740s to 1860s).

Models to Mock-ups

While the curators were busy gathering information and assembling the collections, the designer set to work on a model of the gallery. This model would not only act as a working guide but be used to help persuade people with influence and money that they would be investing in something at once unique and valuable.

There followed a period of remarkable energy, resourcefulness

In this case, the curator decided that economic changes came first, and other changes followed.

and creativity by a still relatively small group of people — the staff, by 1969, had grown to 28.

While two or three of them were canvassing local businessmen for funds and assistance, another was applying for a federal grant to hire students who would assist with research as well as all aspects of construction.

The federal grant became, in fact, an important element in the construction of the new gallery. The person who applied for the grant, in search of an impressive name to put on his grant application, asked for a translation into one of the native languages of the word "Work". The answer sounded to him like "Mamook", so that was the name adopted. At first, the grant made possible the hiring of some 24 people; eventually, "Mamook" supported more than 50, many of whom later became permanent members of the Museum staff.

But the originator and administrator of "Mamook" (a taxidermist who eventually became production supervisor in the exhibits division of the museum) lived through some harrowing months. The cheques from federal grants tended to be slow in coming; consequently, the taxidermist had to raise a personal bank loan of some $25,000 to meet salaries while he waited for the cheques to arrive. Such was the strength of commitment to the success of the new galleries.

By now the structure of the new gallery was becoming firm

Opening 'The Ring': 1920s-1970s

By now the structure of the new gallery was becoming firm. The introduction to the gallery was to exhibit examples of the instruments of progress and development: communications and transport. Dominated by a Fleet II floatplane suspended above the entrance — one of the bush-flying aircraft that helped open up the province — the theme was of all the other technological advances that did the same thing: telephones, radios, roads, television and computers, supported by charts, maps and explanatory labels.

As it turned out, this was the one part of the Modern History Gallery judged to be at least a partial failure; its message was too complex, its layout too confusing. It was later changed to include an array of everyday objects chosen to give the flavour of each

decade — a trip down memory lane.

There were two lessons to be learned in this failure. First, to give an impression of space to the introductory gallery, mirrors had been used extensively. Only a day or two after the gallery opened, a child who had become separated from his mother spotted her and ran towards her — only to collide with a mirror. After that, signs had to be silk-screened onto the mirrors. Second, a number of the artifacts had been mounted on rotating platforms driven by electric motors. Each had some printed text mounted on it and the slower readers, unable to finish reading this copy before it disappeared, promptly grabbed the platform, effectively arresting it and burning out the motor in the process. A more static approach had to be adopted.

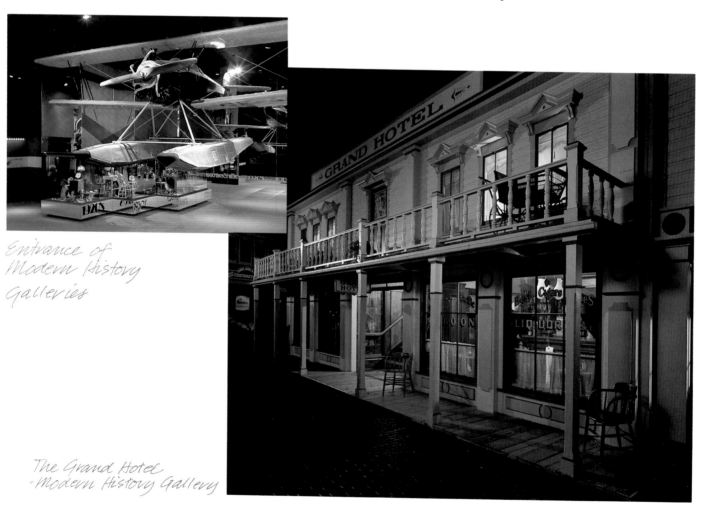

Entrance of
Modern History
Galleries

The Grand Hotel
-Modern History Gallery

16

Cities and Jobs: 1870s-1920s

Passing from the introductory gallery, the visitor was to enter the realm of *Urbanization and Industrialization, 1870s-1920s.* When the gold rush began to fade in the 1860s, businessmen turned to resource exploitation. Coal became the province's major export commodity by 1884. Forestry made equally impressive strides in this period. A wide variety of projects, including railway building, shipbuilding, mining and road construction provided an ever-growing market for timber products. In the 1870s and 1880s, railway surveys uncovered impressive reserves of base metals in the Kootenays. By 1898, several major lead, zinc, copper and silver mines were in operation, all with the railways and lake steamers available for transportation to smelter or market.

It would be difficult to exaggerate the importance of the railways during this period. They were the cornerstone of industrial development and expansion. They provided not only the means of moving goods to market, but also brought in new immigrants by the tens of thousands — new immigrants who helped to fuel the expansion by demanding not only houses to live in but houses in towns and cities. Many of the immigrants were accustomed, in their homelands, to all the amenities of large urban centres: streets, sidewalks, street lights, transportation and even sewers; hence the emphasis in this part of the gallery on urban development.

The next stage was for the curators to research the buildings and structures they had chosen to include in the exhibit — the environment in which the artifacts would be displayed — to produce detailed blueprints for the designer, and to decide on a scale. To accommodate the 'street scene' the curators had in mind in the space available, a scale of approximately three-quarters of actual size was adopted, but this varied according to the individual buildings.

The turn-of-the-century 'street scene' portrays, among many other things, a railway station, movie theatre, drapery, pharmacist, a store for sporting goods, a Chinese store, a printing shop, a blacksmith's shop and a saloon, flanked by the parlour of the Grand Hotel. Each building is a replica of an original; the originals were selected from many parts of the province.

When the gold rush began to fade in the 1860s, businessmen turned to resource exploitation

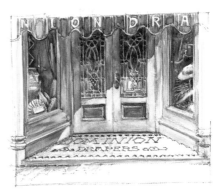

Dominion Drapers Shop
-Modern History Gallery

17

Farming, Fishing, Logging and Mining

Leaving the street scene, visitors move into the "Industry" displays. Clearly these could not be grouped together into one large diorama, or into one environment, as was the street scene; thus the story is told by a large diorama of the spring break-up at the Tremblay farm, a pioneer homestead in the Peace River district, 1912; the interior of a fish cannery on the Skeena River estuary, 1871; the Robinson sawmill, one of the first steam-driven sawmills erected mainly to cut timber and ties for railway construction in the Selkirk and Rocky Mountains, 1889; and the underground workings of a hardrock mine, the Le Roi mine in Rossland, 1903.

Here, for the first time, new experiments in smell were conducted. In the Tremblay farm diorama, small quantities of horse manure were placed near a ventilation fan. Unfortunately, this encouraged an atmosphere that was all too genuine; real flies began to assemble around the diorama. The conservators tried fumigating the manure before it was introduced but the smell of fumigated manure was unacceptable and the attempts to re-create this particular smell were abandoned.

Paradoxically, visitors passing through the underground workings of the Le Roi mine have been known to ask how the dank, oily smell of compressed air, used in all mines, is achieved. In fact there is no oily smell; yet, for people who have worked underground, the atmosphere is so compelling that their imaginations created the smell.

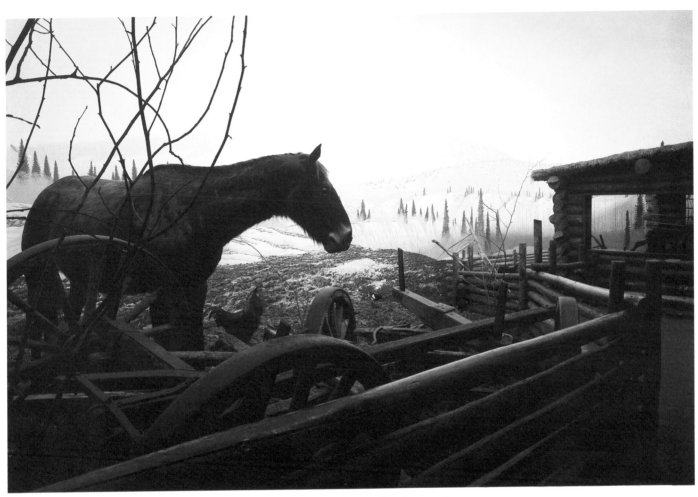

Tremblay homestead diorama - Modern History Gallery

Gold! 1840s-1890s

By now *The Ring of Time* has retreated to this most romantic age of British Columbia's history, which was profoundly affected by five gold rushes between 1848 and 1898. First there was the boom in California and Colorado (1848-53) that drew large numbers of Britons, many of them Hudson's Bay Company employees. Second, the Fraser River strikes (1858-59) brought tens of thousands of men into the British territories, forcing Hudson's Bay Company and British colonial officials to create a new colony, British Columbia. The Cariboo gold rush (1862-66) strengthened Victoria's hold on colonial politics and commerce, while the Kootenay and Omenica rushes (1870s) pushed the province's frontiers to their present limits. Finally, the Klondike (1897-99) gave Vancouver effective financial and economic control of the north Pacific coast.

Although the gold rushes drew many thousands of miners, few of them stayed after the gold ran out

Although the gold rushes drew many thousands of miners, few of them stayed after the gold ran out. In truth, miners like Billy Barker — who struck it rich — were few and far between; the real bonanzas almost invariably went to the merchants, shippers and financiers who "mined the miners", becoming wealthy and influential in the process. For British Columbia, these groups made lasting contributions because they remained in the region, investing in transportation, urban development and, of course, resource industries.

However, the most important impact the gold rushes had was that they opened up the province and extended its boundaries

However, the most important impact the gold rushes had was that they opened up the province and extended its boundaries. Roads had to be built, rivers and lakes became the proving grounds for steam vessels — stern-wheelers and side-wheelers. The transition from horses and water power to steam made significant progress during this era.

But for all the richness of human experience, for all the glamour of the gold rushes, they did not provide very much that was visually effective in a static display. Mannequin dancing girls and prospectors just don't work very well. Instead, the curator and designer settled for a fully operational, water-driven Cornish wheel (a device that provided power for winches, pumps and sluicing mechanisms) set in a large diorama portraying a Cariboo scene.

So, although the vitality of the saloons, with their grizzled miners and dance-hall girls, cannot be re-created, school programs

make it possible for children to recapture some of the excitement of the Gold Rush by panning for gold from genuine Barkerville sand, beside the creaking water-wheel. The gleam in their eyes when they see the thin yellow streak on the edge of their pans goes right back to the last century.

The gleam in their eyes when they see the thin yellow streak on the edge of their pans goes right back to the last century

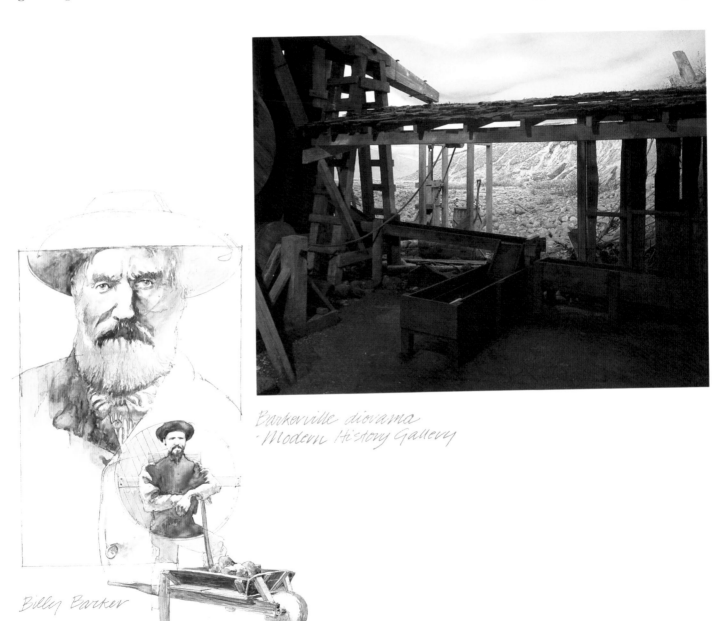

Barkerville diorama - Modern History Gallery

Billy Barker

From Canôt du Nord to Discovery: *1740s-1860s*

One of the unavoidable problems facing the curator and designer for this phase of the Modern History Gallery was the shortage of surviving artifacts. When people had to carry everything they needed, either in small sailing vessels, even smaller canoes, or on their backs, they tended to discard any piece of equipment as soon as it became unserviceable. Yet the principal means of transport, the sailing vessels of Quadra, Cook and Vancouver on the sea, and the celebrated birch bark *canôt du nord* (north canoe) used by MacKenzie, Fraser and Thompson on the lakes and rivers, had to be represented if this part of the Gallery was to come to life.

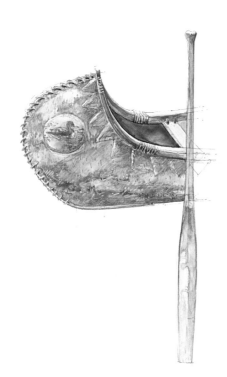

The north canoe could be re-created without too much difficulty. The curator had access to historical descriptions and drawings; a craftsman mature enough to have maintained the skills required was available to build it. The ribs and gunwales were moulded and carved to give both strength and the streamlined shape to the shallow but spacious hull. For a covering, layers of golden birch bark were laid side by side and stitched together with spruce roots; the seams were then sealed with tree gum. The bow decorations are a personal touch, but really the only one because there was a standard hull pattern followed by all builders.

When it came to the replica of a sailing vessel, however, the curator and designer were faced with a much larger problem, both in scale and the availability of expertise. They wanted to display Captain George Vancouver's H.M.S. *Discovery*, but the detailed information required to match the historical fidelity achieved in the rest of the Modern History Gallery resided in the National Maritime Museum at Greenwich, in England. They considered sending a curator there to do the necessary research but happily there was someone in Vancouver who had acquired this expertise by years of research. He, together with a shipwright who was old enough to have worked on sailing ships, enthusiastically set about producing the accurate, full-scale replica of the stern of *Discovery*.

Visitors who arrive at the ship from the fur trade gallery are usually startled by its presence and bulk. For the sake of historical continuity, the ship is entered from the side representing Nootka Sound on the west coast of Vancouver Island. When leaving, visitors step off onto a wharf typical of many in eighteenth-century

England. But before doing so, there is opportunity to move about inside and view the Captain's main cabin as well as the senior officers' quarters.

The *Discovery* was home to 100 men during its long journey to these waters and, despite its small size, it was relatively comfortable in heavy seas. Unlike today's governments, which supply virtually all the equipment and supplies needed by their naval crews, eighteenth-century admiralties rarely gave the officers and men any personal kit. Thus seamen, including the captain, would bring aboard a curious assortment of tools, bedding, clothing, utensils, soaps and, in the case of officers, cabin furniture as well as their own china and silverware.

To store and safeguard their smaller and more precious possessions, sailors usually purchased a seaman's chest equipped with an intricate locking mechanism. An example of this is seen beside the captain's bed space. This chest, somewhat larger than normal, is believed to have been used by George Vancouver when he sailed as a boy seaman with Captain James Cook.

The Discovery was home to 100 men during its long journey to these waters and, despite its small size, it was relatively comfortable in heavy seas

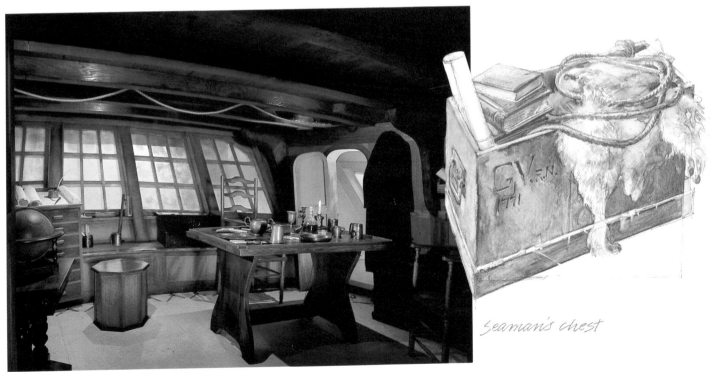

Captain Vancouver's cabin, HMS Discovery

seaman's chest

23

The replica of the *Discovery* was the culmination of the Modern History Gallery. For more than two years the Museum's staff had been totally involved with the project; the question of overtime apparently never arose during this period. As could be expected, any number of problems had to be solved and there was a constant, nagging anxiety about funds.

In spite of this, the curator and designer had set an inexorable deadline for completion. Two years after construction commenced, the Gallery had to be ready for public viewing. As the time approached, there were the perhaps inescapable last-minute crises. The most disconcerting of these involved the wooden cobbles in the street scene. After they had been laid, a residue of sand remained, a residue that had penetrated every corner. The designer ordered a complete wash down with hose and water. Unfortunately, the water caused the wooden paving blocks to swell, some more than others. The result was a dangerously uneven surface, which had to be lifted and relaid during the long night before the opening ceremonies.

The Modern History Gallery was officially opened to the public by Premier W.A.C. Bennett on July 7, 1972, two years to the day after the first construction nail had been driven. If numbers reflect approval, the Gallery was an undeniable success. Attendance reached 1.1 million that year. Since then more than a million people a year have seen the exhibit and the majority were obviously impressed. For the staff, it was time now to move to the next phase of *The Ring of Time*.

The
12,000-Year
Gap and
First Peoples
Story

The 12,000-Year
Gap and
First Peoples Story

Ideas: Old Versus New

B efore continuing our journey along *The Ring of Time*, we must pause and go back in real time to 1968, the year the new museum opened. All had not been sweetness and light in the genesis of the present exhibits. In fact, the two years of gestation, 1968 and 1969, before actual construction began on the Modern History Gallery, were turbulent ones.

The problem centred around design philosophy. The designer on staff at that time was a traditionalist and the curators found themselves at odds with his ideas — they wanted something more than display cases and labels but they were none too sure what that something more should be.

By this time, two decisions had been reached. First, that a display representing the archaeological history of the province would be named *The 12,000-year Gap* — a reference to the gap in our knowledge that occurred between the end of the last ice age and the arrival of the white man. Second, that the display of the history of the native people would be named *First Peoples* — an obvious reference to the fact that the Indians were the first people to inhabit what we now call British Columbia.

Plans for the latter had made some progress. As a centre-piece, an actual cedar, log and plank, Kwakiutl 'big house' was to be built in the Museum. This was a complex undertaking. If the 'big house' was to be genuine according to Indian tradition, it had to belong to a real Kwakiutl family — preferably a distinguished one — and would have to be 'potlatched' by that family. Potlatching, the traditional dancing, feasting and giving of gifts, would confirm the family rights. Clearly, this was an unusual situation — a private residence in a government-owned building — and one that had to be handled with considerable tact. Eventually, an agreement was reached which left the physical structure, as well as everything it contained, in the possession of the family. The agreement also embraced the less-tangible possessions, such as the songs to be sung (which is why no tape recording is allowed) and the dances to be performed.

However, when the designer took over, he cut off a third of the house and tucked the remaining two-thirds in a corner. Worse still, the truncated house had a steel beam running down the

middle of the roof; the remaining beams were constructed of styrofoam. The whole thing, in the words of one curator, "looked awful."

Potemkin to the Rescue

With this background, tensions mounted as the attempt to produce an overall theme for the new galleries continued. In the end the Director of the Museum decided to defuse the situation by calling in an outsider for advice. The director of the Milwaukee Public Museum was selected. He was a flamboyant man (a Hungarian Count, heavily be-ringed, pomaded and dressed in the style of a nineteenth-century dandy), chosen because the Milwaukee Museum was much in the news at the time for its originality — particularly in its representation of a Milwaukee street scene at the turn of the century.

Much to the relief of everyone (except, no doubt, the designer) the consultant recommended that all the existing displays should be thrown out and a fresh start made. He proposed what he called 'The Potemkin Solution'; in other words, the practice of illusion in an exhibit.

Potemkin, a powerful minister in the court of the Czarina Catherine the Great, was responsible for the colonization and development of new territories in southern Russia. To demonstrate to Catherine his achievements, he arranged to conduct her on a grand tour down the Dnieper River. The story goes that the villagers along the Dnieper were actually starving. When Potemkin discovered this, just before the tour was about to begin, he faced a crisis. In eighteenth-century Russia, the penalty for deceiving the monarch was almost invariably terminal.

However Potemkin, according to his detractors, was not just a liar; he was an extremely resourceful one. He sent an advance party to build prosperous-looking facades to the towns and villages fronting the river, together with a sizeable crowd of well-fed citizens to wave and cheer. As the royal barge progressed down the river, Catherine observed all the signs of prosperity she needed to reassure her. Potemkin survived and her subjects continued to suffer.

Historians have long since dismissed the story of 'Potemkin's

villages' as false, but it lives on as a symbol of deception or, at any rate, of illusion.

Meanwhile, back in Victoria, acceptance of the consultant's advice to make a fresh start left the way clear for a new designer — the incumbent resigned — and for a start on the Modern History Gallery.

The Story Line: A Fresh Start

But, while the story line for modern history had more or less fallen into place, no such comfortable outcome had been reached for the next phase of *The Ring of Time*. Curators had been wrestling with the problem for the two years during which the Modern History Gallery was being built. A sort of agreement had emerged that tribes, or language groups, of the native peoples would be dealt with separately: their technology of food gathering, canoe and house building; their social structure; their ceremonies; their politics; and their cosmology, or religious beliefs — each would stand alone as a unit in the whole. This was to be accomplished by geographical groupings. Progressing up the Fraser Valley, the language groups would be represented, one at a time; then those in the Interior as far as the Kootenays; and finally, the display would switch to the north coast, before returning to Vancouver Island.

There were, however, serious flaws to this story line. To begin with, there was bound to be a good deal of duplication in the progressive groupings of displays. Secondly, the collections were not comprehensive enough to furnish all the aspects of all the language groups. Relief from this dilemma came in a somewhat circuitous fashion from the Assistant Director of the Museum who was an environmentalist. He urged that awareness of ecology had to play an integral part in each gallery.

At first, the curators contemplated this development with some dismay. None of them had any real expertise — they were not cultural ecologists — but they reacted sensibly by hiring a curator from the University of British Columbia who was. He came to the Museum in the fall of 1973. In less than two months, he produced a story line so satisfying that it was instantly accepted by everyone.

Simply put, the displays would be in layers. They would start

with the environment, the native peoples' technical response to the environment, and then go on to deal with transportation, society and its organization, its art and ceremonies, and finally the beliefs which explained the natural environment in which people lived — even though this explanation was often supernatural.

The new story line brought a fresh stimulus and surge of creativity to curator and designer alike. One of them conceived the idea of a mezzanine around an open, central display area. The truncated 'big house' was scrapped and rebuilt, full size, with genuine cedar beams and planks. In front of the 'big house', the open area would constitute an art gallery — one that could be looked down on from the mezzanine, and one which created a satisfying sense of spaciousness.

Simply put, the displays would be in layers

12,000 Years of Nothing — But Bits of Stone and Bone

However, while detailed planning for *First Peoples* progressed rapidly, another problem remained unresolved. *The Ring of Time* called for a giant stride from Captain Vancouver's voyage in *Discovery* in the 1790s, back across 12,000 years — the period from the last ice age until the coming of the white man. The only human history to survive from that era had done so in the form of artifacts collected by archaeologists. But the archaeologists themselves were engaged in a philosophical debate. One group maintained that any interpretation of social life deriving from artifacts was little more than speculation; the other felt that displaying artifacts without attempting to assess their significance was an exercise in futility.

This impasse was resolved, in part, by the designer and his staff, whose sense of theatre compelled some element of interpretation. The solution was to display the artifacts, giving as much interpretation as was compatible with scientific objectivity, and to dramatize the display by setting up an actual section of an archaeological dig — a section from the Glenrose site, near the mouth of the Fraser River. The technology was available to do this. The soil on the face of the dig was impregnated with plastic. When dry, the plastic-impregnated soil could be cut out and carried away, like sections of turf, and reconstructed in the display. The archaeologists by now had resolved their misgivings; they dug enthusiastically into their treasury of research and knowledge. Thus, when

30

it was completed, the gallery demonstrated graphically what could be interpreted by the archaeologist.

To complement this introductory display, a large selection of Indian artifacts were shown, together with illustrations of how stone artifacts were created. Even something as apparently simple as an arrowhead requires considerable technical expertise to produce. Fortunately, the Museum's archaeologists had acquired these skills; they could both demonstrate *and* describe them.

From here the visitor was to be moved up to more recent archaeological discoveries, including a display recalling the most celebrated archaeologists who had worked in British Columbia. The gallery ends with a replica of an Interior Salish winter house, or pithouse. Pithouses came in many shapes and sizes. This particular one is a circular excavation with a log framework supporting a cone-shaped roof of logs and poles.

In the absence of caves, our ancestors have used such semi-subterranean houses for thousands of years. In British Columbia, the oldest pithouses known to archaeologists were excavated at Shuswap Lake Park and were occupied 3,200 years ago. But the earliest known examples of these dwellings were lived in 25-30,000 years ago on the steppes of southern Russia.

microblade production

Even something as apparently simple as an arrowhead requires considerable technical expertise to produce

*In the absence of caves,
our ancestors have used
such semi-subterranean
houses for thousands
of years*

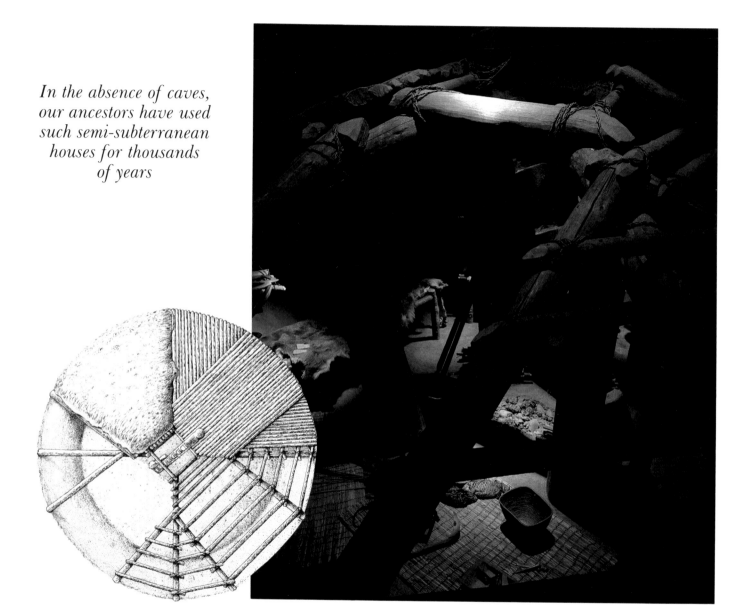

Full scale Pithouse
- Archaeology Gallery

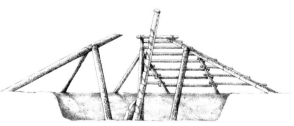

Pithouse plan and cross-section

32

First Peoples: Technology

From the pithouse, stairs lead to the mezzanine, where the story of the First Peoples before their contact with the white man is told. When it came to the history of the First Peoples, no effort was spared to provide an accurate and sensitive treatment. To begin with, the designer and the curator travelled through the Interior and along the coast so that the designer could develop a genuine sense of Indian culture. They visited the village of 'Ksan, near Hazelton; they worked on a gillnetter out of Alert Bay, off the northeast coast of Vancouver Island. The designer was interested in caves, so the curator took him to one on Gilford Island — a cave of particular significance, as we shall see.

The initial exhibits on the mezzanine deal with technology and include an underwater diorama demonstrating methods of catching or trapping fish. The ocean floor slopes upwards from the viewer towards the beach. In fact, this slope is the slope of the roof of the 'big house' below it — a superb use of space. Moreover, the designer was able to use this underwater diorama as a testing ground for similar displays planned for the forth-coming natural history galleries. It was an immediate success. In the pale, aqueous light, people very nearly find themselves holding their breath.

The displays continue with examples of hunting techniques employed to kill sea mammals, as well as the preparation and preservation of food. In a temperate climate, nearly everything from salmon to Salal berries had to be dried, either in the sun or with smoke. The food-gathering displays on one side run parallel, on the other, to what we would now call cottage industries: the production of clothes, furniture and utensils. It is here, as a rule, when standing in front of the case displaying Salish weaving, that visitors first begin to re-examine their concept of the native peoples as they existed before the coming of the white man.

At the end of the eighteenth, and the beginning of the nineteenth century, white men enjoyed a secure sense of their own superiority. The belief that western civilization stood at the apex of human achievement led them to regard North American Indian culture with something not far removed from contempt. Indians were savages, living in a sort of child-like state of arrested development; thus their customs, ceremonies and religious beliefs

Seaweed gatherer

33

could be set aside as irrelevant compared to the white man's enlightenment.

Yet here, abruptly, in front of the Salish weaving display, visitors, who still harbour some remnants of this false sense of superiority, come face-to-face with a highly developed technical and artistic accomplishment: the spinning of yarn from goat's wool and the subsequent use of a loom to weave garments with superbly intricate and beautiful designs — either the crisply geometric designs of the Salish or the shawl-shaped, ceremonial blankets of the Chilkats.

As more and more examples of this technical mastery are revealed, this sense of changing perception grows; there is an increasing awareness of a culture that was at once vigorous and surprisingly sophisticated. The weaving of waterproof clothes and hats from the bark of cedar and roots of spruce; the delicate designs woven into their baskets; the demonstration of how boxes of bent, cedar planks were constructed — boxes so skilfully assembled that they were watertight and could be used as cooking vessels (heated rocks were dropped into them to boil the water). These boxes were almost invariably inscribed with delicately geometric carvings, and then painted.

First Peoples: Contrasts

What gradually emerges in these displays is the contrast between the people who lived on the coast, where food was plentiful and housing semi-permanent, and the people of the Interior, who lived a much more nomadic life. The possessions of the Interior people were usually smaller and more portable — though nonetheless beautiful, as the examples of quill- and bead-work ornamentation on their moccasins and carrying bags demonstrate.

These two life styles are traced in a number of ways. There is a diorama, depicting in miniature a Kootenay village, with its transportable, hide-covered tipis (tents), and the horses that transported them. Horses were first introduced to the Americas by the Spaniards in South America in the 1500s. Gradually, their acceptance for hunting and as a means of transport moved north until, by 1760, the Kootenay Indians were using them.

Below the mezzanine, there is another miniature diorama, this

At the end of the eighteenth, and the beginning of the nineteenth century, white men enjoyed a secure sense of their own superiority

one of Skedans, a coast village. This diorama emphasizes that, whereas the Interior bands lived a nomadic life, following the food supply when they had to, the coastal bands lived in semi-permanent communities, in substantial wooden houses, making seasonal sorties to temporary camps for their food.

But the most vivid comparison comes with the two chiefs, representing the two cultures, each in his regalia. The first is a life-sized model of an Interior Salish Headman, impressively arrayed in his finery. In fact the headmen of the Interior villages did not enjoy the same power or influence as their coastal counterparts, even though marriages and other alliances between the 'nobles' of different bands were an important part of the social structure. In the small villages of the Interior, matters like the settlement of disputes, the distribution of resources and the regulation of the band's movements did not require a complex social or political organization. Most villages were composed of a few extended families; consequently, nearly all political matters were settled at the family level.

This meant that though village headmen were recognized, none could compel their fellows to follow or obey them. Instead, leaders had to rely on the respect accorded their judgement, wisdom, or skill at hunting. If a more able or persuasive figure emerged, he could replace the incumbent.

First Peoples: Society

The coastal culture is represented by a chief, whose power and influence, on the other hand, were much more substantial. In this case the chief is a Tsimshian and he had two principal roles. As head of his family, he controlled its economic resources and ceremonial privileges. In his other role, the chief was called 'Great Dancer' and was responsible for handling dangerous supernatural power for the benefit of the community. Moreover, the social structure of the coastal people was more complex. Marriages between nobles were regarded as alliances between kin groups rather than simply unions between individuals; they were arranged with a view to the social and economic advantages to be gained from them. Sons and daughters of highest ranking nobles usually married persons from other villages, thus extending the network of kinship and alliances and increasing the connections

of the kin group and, incidentally, avoiding the consequences of inbreeding. These weddings were attended with much pomp and ceremony, as well as lavish exchanges of wealth.

Although coastal society varied widely from north to south, it was everywhere based on two related principles: rank and property. Each free member — slaves were also part of the social fabric — each free member of a village held a particular status, unique to him and ranked in relation to all the others. And each status was hereditary. The higher positions carried, besides a name or title, a host of rights and privileges, such as control of certain fishing grounds, ownership of particular songs and dances, or membership in secret societies.

Although coastal society varied widely from north to south, it was everywhere based on two related principles: rank and property

First Peoples: Explaining their World

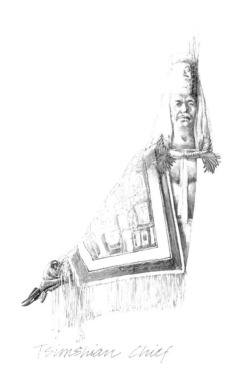

Tsimshian Chief

Food, and the relative ease with which it could be gathered and preserved, left the coastal peoples with time to celebrate their rituals and cultivate their art, both of which found much of their expression in the cosmology, or religion.

Man has always had difficulty when confronted with the mysteries of the world surrounding him. The usual reaction is for him to create a mythology that explains the universe, and thus explains the world as he experiences it. These myths are then woven into a cosmology. Cosmology is a difficult word. Nowadays it has connotations of astrology and the fortune teller; but, if we can risk one more attempt at a definition, the cosmology we are talking about is a system which presents, symbolically, the relationships between people, nature and the supernatural.

Perhaps one of the most significant aspects of the cosmology constructed by North American Indians was that it did not necessarily revolve around man. Most of the visible symbols of their cosmology — the masks and the totem poles — concentrated on animals: the raven, bear, killer whale, eagle and beaver, among many others, were central to the myths explaining the origin of man.

36

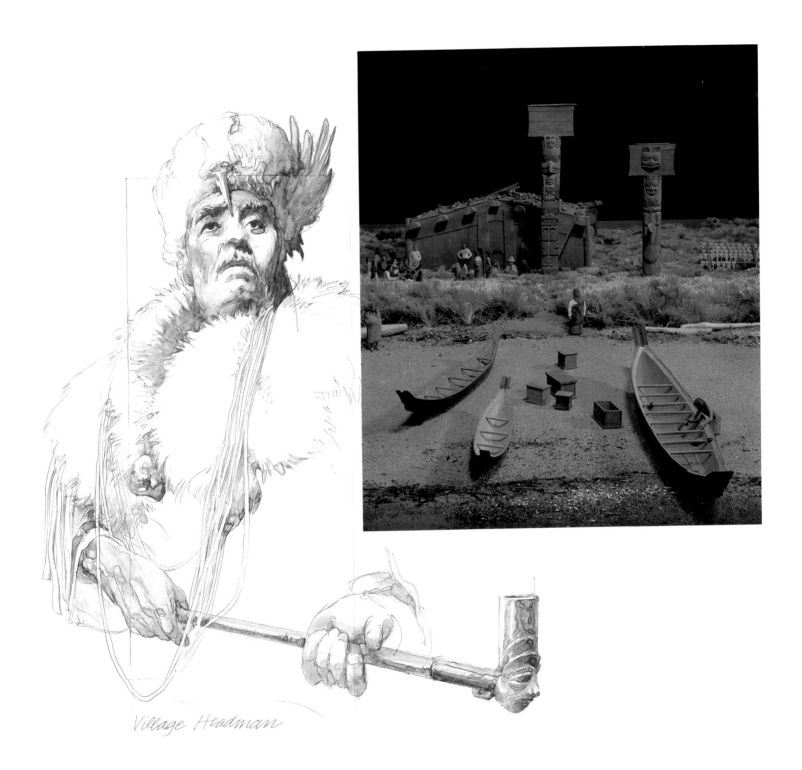

Village Headman

37

As with most religions, ritual, which in this case usually took the form of stylized dances, was supremely important. To quote from a statement in *First Peoples*:

> *Basic to Indian mythology is the knowledge that human life depends on a healthy and structured natural world. In order to ensure a delicate balance between nature and human activity, appropriate acts of ritual were conducted at times of seasonal change, of important economic activity, or of human crisis.*

This is not far removed from the white man's Maypole dance or harvest festivals — except that the white man invariably relegated the animals in his environment to a subservient position.

The masks on display, therefore, represent in symbolic form the myths that go to form this cosmology. They are so vividly created, so beautifully crafted, that people either linger in rapt admiration or hurry away from them, apprehensive about insights and intelligences which existed long before their own more materialistic view of the universe was passed on to them.

Basic to Indian mythology is the knowledge that human life depends on a healthy and structured natural world

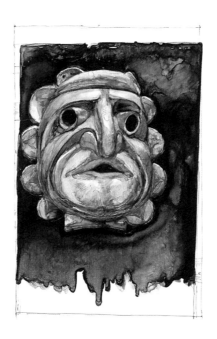

The Shaman: The Link Between Human and Supernatural

After the masks, come the Shaman's regalia and accoutrements. The Shaman was one of the more important people in the community. He was responsible for maintaining the correct relationships between the natural, supernatural and human worlds. He was the equivalent of the priest or the witchdoctor in other cultures, and one of his more important roles was to cure human sickness.

The Indians believed that sickness was the result of possession by evil spirits, witchcraft, or the loss of the soul. At the same time, they had developed a considerable understanding of natural remedies or 'medicines' extracted from plants. These remedies could be applied by anyone for the more common ailments. When it came to a more serious illness, however, the Shaman was called in. He, too, might use the more traditional herbs and nostrums, but he was also able to exorcise the evil spirits with his charms, puppets and rattles. His powers were not hereditary; he had to serve an 'apprenticeship' and he acquired his songs and spirit charms in visions which came to him during mystical experiences.

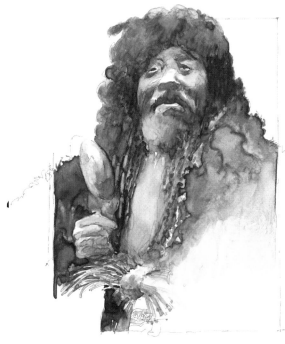

Tsimshian Shaman

The Shaman was one of the more important people in the community

39

And Then Came the White Man

And then came the white man with, on the one hand, his enticing manufactured goods — his knives and beads, his nails and axes and guns — which seemed so desirable; on the other hand, the culture and religion so incompatible with that of the native peoples.

For the Indians, the first contacts did not seem ominous. They did not understand how significant the seemingly simple ceremonies of the white men were; in fact, these ceremonies represented a conversion of the Indians into subjects of King George III — with the eventual implication of conversion to Christianity, a religion which turned out to be in conflict with their own.

The remainder of *First Peoples* illustrates the profound effects of the white man's culture on the Indian's traditional way of life: the adoption of metal tools and implements; the gradual impact on their art; the well-meant but disastrous effect of the missionaries; and the calamity of diseases to which they had little or no immunity. It is a disturbing litany, portrayed in this instance without bitterness but with a good deal of sadness.

his is what you see now but the making of an exhibit requires much more than a story line, a design drawing, and sympathy for the material. These are merely the beginning of the process. After them, what seems like an endless series of decisions has to be made; endless problems have to be solved. The appropriate artifacts and objects — be they baskets, masks, silver bracelets or fillets of dried salmon — have to be selected. Then the curator has to make sure they are catalogued, given a number and photographed so that there are no embarrassing mistakes when the descriptive words (called the copy) are written.

Beyond the simple physical organization of the artifacts, too, there are the technical problems — the constant attempts to improve the illusion of reality. The underwater diorama demonstrating Indian fishing methods is an excellent example. Nothing similar was available to show the way. Thus the first challenge was to create the impression of slightly murky water, several feet below the surface. The solution, after several failures, turned out to be the use of layers of bridal veil, its virginal white transformed by dye to an aqueous grey. Then light was directed through a sheet of murky plexiglass at the back of the diorama. Finally, a sheet of polyethylene was stretched across the top to resemble the surface of the water as seen from below.

This solved the problem of lighting, but then each item in the diorama had to be made. How, for example, do you fashion fish that look as though they are alive? The first attempt was to make a mould from a recently caught salmon and then cast the model in fibreglass. The result was a fish that looked not only as if it had been caught but as if it had given itself up. It looked like a *dead* fish.

The solution was for the model-maker to sculpt a salmon in material resembling plasticine. A mould was made from this sculpture and the model cast, once again, in fibreglass. When the artist had coloured the fish, we had something that looked capable of putting up a fight. The same method was used to produce the herring and cod.

And so it went with all the other details in the diorama; a process of trial and error. The stalks of the kelp (seaweed) were cast from the moulds normally used to cast fibreglass fishing rods,

Beyond the simple physical organization of the artifacts, too, there are the technical problems — the constant attempts to improve the illusion of reality

which tapered realistically. The leaves were made of vinyl. The fish traps and the herring rakes were constructed from descriptions written by the celebrated anthropologist, Franz Boaz, some 80 years earlier. At each step of the way, new methods had to be tried and discarded, if they failed, or adopted if they were successful.

At each step of the way, new methods had to be tried and discarded, if they failed, or adopted if they were successful

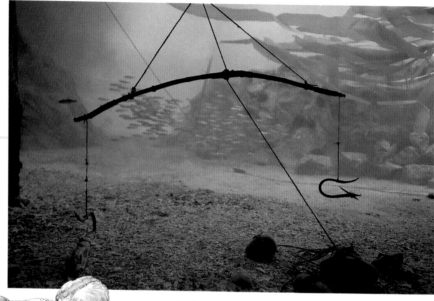

Fishing techniques diorama
-Ethnology gallery

Sculpting and Mouldmaking
-Ling Cod

42

By way of a small digression, there was a spirited debate about what kind of a model should be used to sculpt the woman in the Salish weaving display. The curator favoured a mature woman, placidly working at the loom. The designer fancied a sylph-like maiden. You will see that the designer won this argument. The young woman portrayed has an enviably slim and shapely body. If some of the reports of Captain Cook's sailors are to be believed, the truth has not necessarily been violated.

The Potlatch: The Delicate Balance

When it came to the art gallery, there were, to begin with, no serious problems of technique. A display case was given to each major language group — the Southern Kwakiutl, the Northern Kwakiutl, the Bella Coola, the Haida, the Tsimshian, the Nootkan and the Coast Salish — and the art which has received international recognition for its beauty and fulfilment glows in the soft light. But for the centre-piece, the 'big house' and the cave, there were social and legal problems — as well as technical — to be solved. The ceremony required to make the 'big house' an actual one, rather than a symbolic replica, was called the potlatch. Both the concept and the significance of the potlatch are not easy to grasp at first. To the white man, it looked very much like social one-upmanship — an attempt by the Smiths to outdo the Jones by throwing a bigger, flashier and more extravagant party — and it was this erroneous concept that caused the almost irrevocable damage to the native peoples' culture.

One of the principal aspects of the potlatch is the ritual giving of gifts to the guests by the host who has called a potlatch to demonstrate his or her family claims to the myths and symbols, the songs and the dances, which will then belong, and be seen to belong, to that family. To the Indian of the Northwest Coast, myths and symbols, songs and dances are as tangible as pots and pans are to the white man. Yet the early white settlers, and particularly the missionaries, saw in this ceremony some elements of idolatry; worse still, their deeply instilled Puritan ethic was affronted. In the giving of gifts, the Indians were simply irresponsible and profligate; they were bound to impoverish themselves and eventually starve to death. The Anglican faith at that time tended to the view that the rich were rich because they worked hard to accumulate possessions, cherished those posses-

To the Indian of the Northwest Coast, myths and symbols, songs and dances are as tangible as pots and pans are to the white man.

Alert Bay Potlatch

43

sions and conserved their assets; whereas the poor were poor because they deserved to be.

The problem with this short-sighted view was that it ignored the fact that the potlatch, as a social, religious, and economic ceremony, had evolved over many centuries and that, as far as gift-giving was concerned, it was a two-way street. The people who dispensed gifts at their own potlatch would be the recipients at someone else's. A delicate balance was achieved before the white man arrived to topple it.

And that, unfortunately, is just what the white man did. Missionaries, supported by the government's Indian Agents, were responsible for Section 114 of the Indian Act of 1886, which made potlatching illegal. Before the Act was quietly dropped in 1951, it came very close to destroying Indian culture.

A delicate balance was achieved before the white man arrived to topple it.

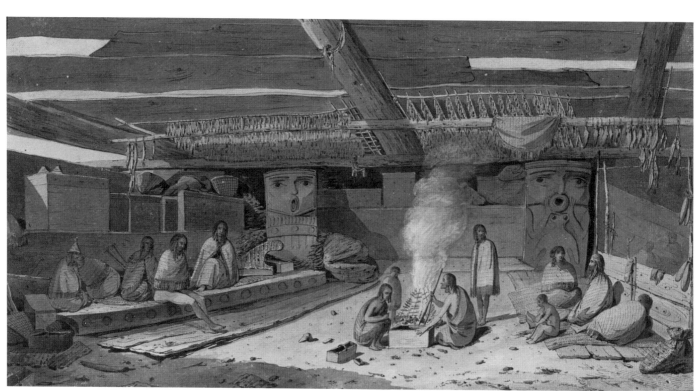

nootka sound house interior - Webber watercolor

The 'Big House' Is Potlatched

For this reason, the Museum was determined, not only to preserve what art and culture remained, but to try to revive it among the contemporary Indian peoples. And one of the ways to demonstrate a return to traditional Indian culture was to include a house in the Museum which had been formally potlatched. The house belonged to the late Jonathan Hunt, a Kwakiutl chief who was born and spent his life in Fort Rupert, on northern Vancouver Island. Hunt threw a potlatch in Alert Bay to establish his claim to the house and the family privileges shown within it. Architectural details, applied designs and ceremonial furnishings are all, as with the songs and dances, inherited privileges acquired through marriage or passed down from generation to generation in one's own family.

As a consequence, the Hunt house stands not only as an actual house, but as a symbol of the continuing traditions of Indian culture; and members of the Hunt family are still practising their art in the Museum today. Indeed, members of the Hunt family, and other Kwakiutl people, often come and sit in the house to listen to the music and relive the past.

The Cave of the Dancing Animals

Beside the 'big house' is a re-creation of the cave called *Nawalagwatsi*, the cave near the village on Gilford Island mentioned previously. The cave is constructed from moulds of actual rock, cast in fibreglass. Its significance depends on a myth: the dance of the animals, a dance belonging to the late Mungo Martin, a chief from Fort Rupert. This dance is based on a legend that long ago, when the world was young, animals gathered to dance in the cave. While dancing, they began to suspect that they were being watched. Four times the mouse was sent out to the mouth of the cave to determine if any intruders were present. But the mouse saw none.

Relieved, the animals — a raccoon, a kingfisher, an owl, a marten, an otter, a squirrel, a deer and, of course, the mouse — retired behind the dance screen and then returned to dance in human form — that is without their masks. It was then they discovered that a man had been watching them all the time. They were

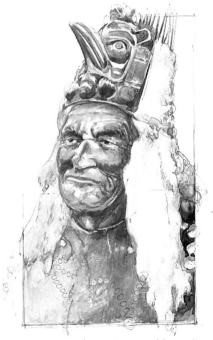

Jonathan Hunt

45

so embarrassed they eventually decided to give the man their dance. The man was an early ancestor of Mungo Martin and the dance was handed down from one generation to the next until Mungo received it.

The dance cannot be constantly re-enacted in the gallery, but the recordings of the songs are played and the masks, glowing eerily in the dim light of the cave, gaze out from its walls. It is a scary experience for nearly all children — and for many adults as well.

The 12,000-year Gap and *First Peoples* were opened on January 17, 1977. Like the Modern History Gallery, they have stood the test of time. With few exceptions, they were accepted as a sensitive, enlightened and highly effective portrayal of both the prehistory and the history of the native peoples of British Columbia. Now it was time to move on to what promised to be the most challenging permanent exhibit in the Museum: the Natural History Gallery.

. . . The masks, glowing eerily in the dim light of the cave, gaze out from its walls

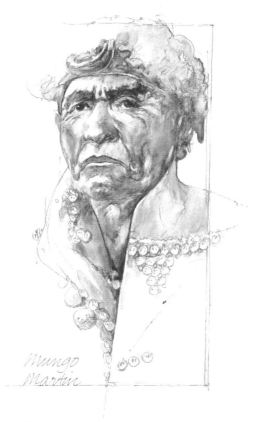

Mungo Martin

Living
Land,
Living
Sea

Living Land, Living Sea

The Natural History Gallery posed the biggest challenge to the curators and the designer for two principal reasons. First, it would involve four disciplines within the Museum: Botany, Vertebrate Zoology, Marine Biology (later to be renamed Aquatic Zoology) and Entomology. Second, because, whereas reproducing man's physical environment is, technically speaking, relatively easy, reproducing nature is a far more complex and demanding proposition. Stuffed animals are feasible but you can't stuff a Douglas-fir or a Camas Lily.

Where to Start?

Before facing the technical problems, however, the curators had to find a story line, some way of selecting, from the vast natural profusion of this province, what should and could be displayed. There was some urgency because this display was to have preceded *The 12,000-year Gap* and *First Peoples* but the story line eluded the curators. Each discipline tended to favour its own area as the most important; each curator wanted to tell the entire story of his or her discipline. A committee composed of curators and the designer had been set up to produce the compromises necessary. The committee decided to start the exhibit with material predating the last ice age and trace the geological evolution of the province. Unfortunately, there was no geologist on staff. Deadlines were reached without consensus and the creation of the Natural History Gallery was shelved while *The 12,000-year Gap* and *First Peoples* were being built.

When deliberations resumed in 1974, the Director chaired the committee. His first move was to resolve the debate about geological evolution. The story was to begin after the last ice age. The retreat of the ice, in his words, "was like pulling back a blind."

The next problem to be addressed was the question of "systematic" displays versus "biotic" (or life) zones. A systematic display would offer specimens of all species found in the province: all the plants, the birds, the mammals, the fishes, and so on. A biotic zone, on the other hand, would display certain areas of the province in units that would in fact be full-scale dioramas, together with a selection of the plants and animals to be found in those zones.

This was a difficult problem. Traditionally, museums of natural history have had systematic displays so that students and scientists could verify their field observations against actual specimens. An attempt was made to integrate the two approaches but lack of space made this impossible and biotic zones won out — at least for the initial phase of the gallery.

The natural history galleries would occupy the second floor. The plan finally decided upon would follow the same concept as *The Ring of Time*, except that there would be no *closing* of the ring. The story would progress in linear time from the past to the present. The theme was that nature is never static; things are constantly changing. The first phase was to be called *Living Land, Living Sea*. There would be some representation of the ice age, followed by displays showing the gradual regeneration of the plants and animals as the ice retreated until, finally, the viewer would be back in the familiar world of mature forests and the reality of a contemporary seashore.

This plan moved away from the text-book approach to natural history: the geological evolution of the land

This plan moved away from the text-book approach to natural history: the geological evolution of the land. Instead, once the regeneration had been demonstrated, five or six biotic zones were to be chosen and these would much more vividly recapture the flavour of our environment.

The Last Ice Age

When the climate began to change and the ice began to retreat, some 12,000 years ago, what was left was a barren expanse of bare rock and debris

But the story in this gallery really begins 15,000 years ago when what we now call British Columbia was in the grip of the most recent of a series of ice ages. What we call an ice age is, in reality, one immense glacier. In British Columbia, with a few possible exceptions, like the Queen Charlotte Islands, and the Brooks Peninsula on the west coast of Vancouver Island, this glaciation is thought to have covered the entire province up to a depth of 2,500 metres. When the climate began to change and the ice began to retreat, some 12,000 years ago, what was left was a barren expanse of bare rock and debris. Fortunately, however, an ice-free area had also existed to the north in what is now Alaska and part of the Yukon. It was called Beringia, and there was a land bridge connecting it with Asia (the land bridge was old sea floor, exposed when ocean levels were drastically lowered because the huge glaciers held so much of the world's water). It was from

these unglaciated areas, as well as from the south, that life began to recolonize the land as the ice retreated over the next 6000 years, leaving only remnants of glaciers high in the mountains or in the far north.

A New Land Emerges

The first plants to re-establish themselves, as the ice retreated, were lichens, hardy pioneers capable of tolerating low temperatures and requiring little moisture. These began to accumulate rock dust and sand in cracks and fissures of the bedrock, the first step in making organic soil; this allowed other plants to establish themselves — mainly grasses and low-growing herbacious bushes. As plant life gradually spread, it provided food for insects and other small animals, so they too began to move back in. The process of regeneration had begun. In time, the low-growing plants produced soil to support taller ones. The soil, constantly improved by humus, was eventually suitable for plants like blueberry, willow, and especially alder, which releases nitrogen to enrich the soil. Finally, the soil and its covering of plants was suitable for the germination of a series of forests, the first creating conditions for a second, and so on.

When these forests — in a dry region they could contain Douglas-fir, Englemann Spruce or Lodgepole Pine; in wetter areas, Sitka Spruce, Western Hemlock or Amabilis Fir — ceased to change, a stage called climax forest was reached. If the climate remains stable, the progression will, to some extent, repeat itself after a forest fire and even, eventually, after clear-cut logging.

Scientists have taken soil samples from old lake bottoms in the interior of the province. From the preserved pollen and spores recovered, which can be identified under a microscope, they have concluded that for many thousands of years the forests in the Interior were confined to the high mountain slopes; the upland valleys supported only grasslands. Eventually, some 6,600 years ago, probably because of a gradual change in climate, the forests crept down until they had invested the valleys as well.

Thus the forests were reborn after the last ice age. They were very different from the ones that preceded it but that is the fact of nature. Things are never static; they are constantly changing.

Things are never static; they are constantly changing

Introducing Mammuthus primigenius

nce it was agreed that the process of regeneration after the ice age would be the story line, there was much discussion about the introduction to the gallery. Perhaps because the introduction to the Modern History Gallery had been such a disappointment, curators and the designer alike were determined to provide something at once significant and dramatic.

Among the scores of proposals canvassed was the skeleton of a Blue Whale, by far the largest mammal on earth, accompanied by the skeleton of a man in a transparent scuba-diving suit. Another was to create the pinnacle of a mountain, replete with goats perched on rocky crags. Finally, the idea of a mammoth took hold as the most dramatic symbol of life that lived near the ice, a whole herd of mammoths, in fact, striding down a gentle hill into the main foyer of the Museum. This would certainly have been a spectacular scene, but it was unrealistically expensive. The final decision was to display a single mammoth in its natural environment on one side of the entrance to the gallery; and to create an ice cave on the other.

In support of these two large and spectacular displays, some indication of the other kinds of animals which roamed the province more or less at the same time as the Woolly Mammoth were to be created. These animals, many now extinct, such as the Ground Sloth, the Wild Ass and the Short-faced Bear, had lived in Beringia. These were rather similar to present-day kinds of animals so, while this display required a skilled artist to produce the scale models of the animals, it required no significant technical break-throughs.

With the mammoth, however, new techniques were called for and the story of the recreation of the Woolly Mammoth (*Mammuthus primigenius*) is worth recounting in some detail.

The first difficulty was to find a complete skeleton from which actual measurements could be taken. Next, there was the question of how to construct the body, with all its complex musculature. Finally, there was the problem of finding a suitable hide to cover it, now that there were no Woolly Mammoths left to provide one. The Vertebrate Zoology Division, and in particular its taxidermist, accepted these challenges with enthusiasm.

A search began for what is called an articulated skeleton —

one that is complete and accurately reassembled. Eventually, one was found at the University of Nebraska State Museum in Lincoln, Nebraska. This was 'pay dirt', because the Lincoln museum's curator of paleontology had earned an international reputation as an expert on mammoths. It was he who had supervised the excavation and recovery of what is certainly one of the best-preserved skeletons of the Woolly Mammoth in existence.

Mammuthus *Takes Shape*

The skeleton, that of an adult bull, had been retrieved from a peat bog in Illinois in 1931. When contacted, the paleontologist welcomed the opportunity to put the results of a lifetime of research at their disposal. In June, 1978, the taxidermist and a curator travelled to Lincoln and set about their research and measurements. The paleontologist was able to give advice on many of the details they needed: the positioning of tusks, eye colour, hair texture and so on. On the question of a suitable hide and hair covering, our own people had already proposed a solution, one which met with his immediate approval. They had concluded that Muskoxen, which had co-existed with mammoths, and which still lived in a climate and environment very similar to the ones mammoths had, must have a similar coating of hair.

Armed with the information brought back from Lincoln, the Vertebrate Zoology Division set about getting a ⅙-scale model of the mammoth produced. A wire-and-wood framework was assembled and positioned to duplicate the Illinois skeleton at the reduced scale. When this framework was complete, an artist in the Exhibits Divison modelled the flesh and muscles in plasticine. The model, set up in a miniature diorama, portrayed an adult bull walking up a gradual incline and turning to the left. The setting would be the recently glaciated, sparsely vegetated, arctic-like terrain of British Columbia as it had been some 10,000 years ago. In full scale, standing about 3.2 metres tall at the shoulder, this would surely confront the Museum visitor with a dramatic introduction.

The trick now was to come up with a full-scale, life-like replica — a very different thing to producing a small model. The original concept had been for a steel structure over which fine mesh wire would be stretched. The mesh in turn would be covered with a

layer of papier mache and plaster, and then moulded. Just as this method was being considered, news of a new technique, used to enlarge a small Inuit carving called *Bird of Spring* to a 2.5-metre statue at the entrance of an art gallery, came to hand.

The process involved the use of stereoscopic photographs of the model, which were projected onto paper and enlarged six times. The result was a contour map of the full-size mammoth. Using these maps, in conjunction with a high-speed cutting head, somewhat similar to a dentist's drill, styrofoam blocks were cut along the contour lines until all the sections were shaped. Finally, these sections were glued together, supported with a framework of wood and metal and delivered to the Museum in December, 1978.

A month later, the foam model had been moved to its final location at the entrance to the gallery, in its diorama, with frost-tempered shrubs and grasses, covered with a light powdering of snow. The mammoth, contoured in one-centimetre steps, was convincingly accurate. Now began the task of smoothing the contour lines, sculpting the musculature and fabricating toe-nails, tusks, trunk and ears.

In the meantime, the search for Muskox hides in the Arctic was going on. A source was found in the community of Grise Fiord, on southern Ellesmere Island. The community had a co-op store which was able to provide six hides taken the previous season. Three more could be promised by the following year, 1979. In the end, these nine hides proved ideal for the task.

By trial and error, the taxidermist discovered that the hides had to be cut in very thin strips to avoid adding too much bulk with the densely woolled hides. Beginning at the feet and working up, much as one would shingle a roof, strips of hide were glued and stapled to the model. Hair colour and length were alternated and blended to achieve a consistent tone. Any viewer will immediately appreciate that the Woolly Mammoth in the British Columbia Provincial Museum is a triumph of the taxidermist's art.

By contrast, the ice cave was a relatively simple task. Carved out of smooth styrofoam, it become a question of artistry rather than technical innovation. A good deal of experimentation was required before the lighting successfully conveyed the blue-white gleam of real ice. It was here that the story of the gallery really began. The ice retreated; the Director's "blind" was being pulled

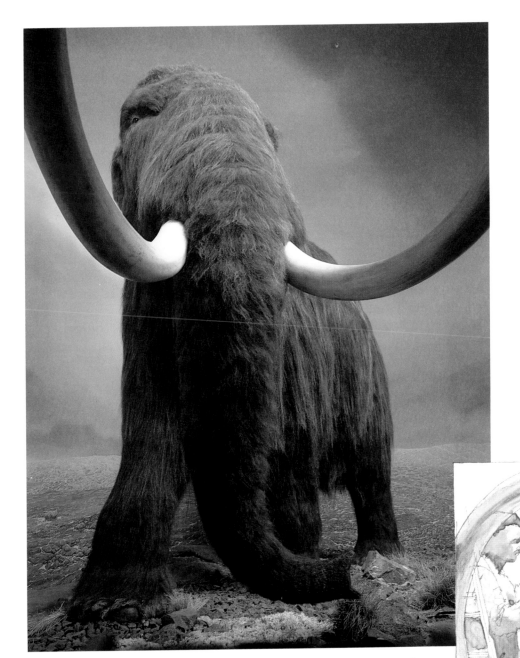

Any viewer will immediately appreciate that the Woolly Mammoth in the British Columbia Provincial Museum is a triumph of the taxidermist's art

Woolly Mammoth (Mammuthus primigenius)

As an aesthetic experience, the display is an undoubted success

The platform would also provide a base for the plastic tent, required for weather protection and to accelerate the curing of the latex rubber used for the moulding.

The tree was stripped of all its moss, lichen and fungi. The stripped trunk now offered a clean impression of the bark. The area to be cast in latex, approximately six metres up the trunk and three-quarters of the way round it, was outlined with tape. The ladders were put in place and the technicians, wearing masks and protective clothing, set to work with brushes and buckets of latex, brushing thin layers of latex on the tree to an eventual thickness of ten layers.

But, if the mould had been removed now, it would have un-rolled as a flat layer; so a rigid jacket had to be made to support it. The mould was covered with a thin sheet of polyethylene to keep the jacket from sticking to it; then a light-weight fibreglass jacket was formed. Finally, the jacket, with its mould inside, was removed from the tree, carried along the trail to the truck, and driven back to Victoria. There, it went to a contractor who would make the fibreglass and polyester resin cast which would be the final product.

Apart from the difficulty of getting the casting up to the second-floor gallery (it had to be carried up on the escalator), there was still a great deal of work to be done on the replica Amabilis Fir before it would be ready for display. The seams had to be closed; the branches had to be added; the bark had to be painted with acrylic and oil paints; a mixture of latex, sawdust and acrylic was applied to simulate lichen cover; roots were added at ground level and preserved mosses provided the finishing touches.

Remember, this was just one tree trunk. For the 31 trees in the gallery, the process had to be repeated 31 times. It was worth it. As an aesthetic experience, the display is an undoubted success.

Mouldmaking and Plant documentation

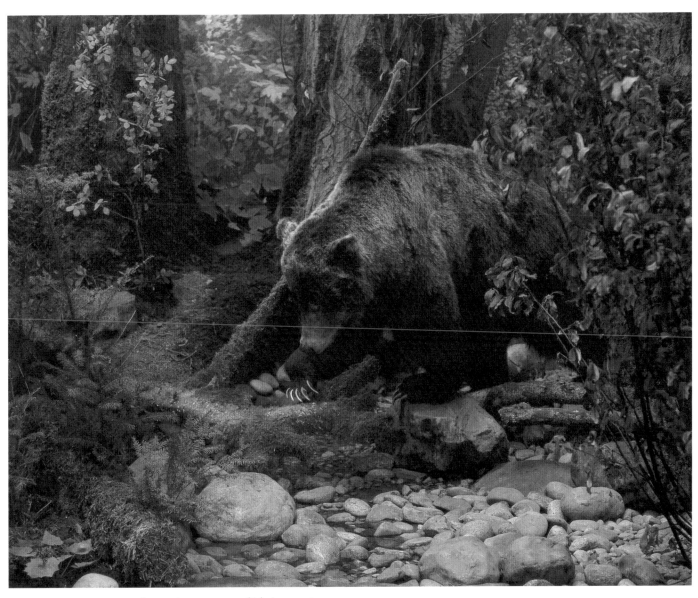

North coast section - Natural History Gallery

59

The visitor emerges from the tranquil light of the forest on to the western shores of Vancouver Island: the cliffs of Barkley Sound, the sands of Long Beach, the cliffs of Triangle Island, complete with nesting birds, seals, sea-lions and a host of smaller creatures.

Here again, authenticity was the keynote. The rocks were cast in fibreglass from moulds taken in the areas represented. The cave, with water surging in from the open ocean, is a replica of an actual cave and, to bring the seashore diorama to life, an actual tide pool has been created, filled with living creatures.

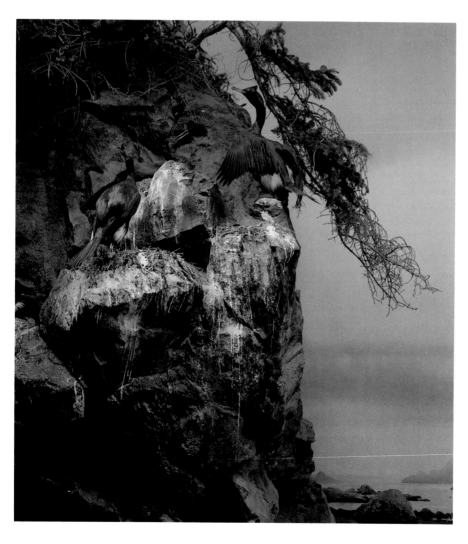

Barkley sound cliff site - Natural History Gallery

A Small Touch of Reality

The tide pool requires continuing supervision by curators and technicians in the Aquatic Zoology Division. The sea water in it has to be kept cool; it is recycled by a pump through a refrigeration unit. The system has worked well but, by its very existence, the tide pool provides an almost irresistible temptation to small people who want to capture and feel, as well as look at, the creatures in it. Security guards take a fatherly interest, restraining the over-inquisitive. One day, a security guard coming to work saw something flopping about in the courtyard outside the Museum. It was a small flatfish. Presuming that some youngster had concealed it in his pocket, and accidentally dropped it, the security guard grabbed the fish, sprinted for the elevator and shot up to the second floor to deposit it in the tide pool. In fact, there had been no flatfish in the pool. In all probability, a gull, under attack from another gull, had had to abandon his dinner.

There have been other minor problems with this 'open' exhibit. The sandy beach is a constant temptation to children, who want to run out onto it to play. Unfortunately, it is not durable enough to withstand traffic. An alarm sounds when this happens and the security guards have to shoo the children away. Another, this time wholly unexpected, problem in the 'forest' arose with the fabricated ground plants, particularly the Salal which, because it is so time-consuming to produce artificially, is an expensive item. People were secreting the plastic foliage under their coats and taking it home with them. The solution was to replace the artificial, within reach, with the real thing. Freshly-cut Salal is now supplied by a contractor and replaced regularly. An added advantage with this solution is the smell of the real plants. The 'forest' becomes just a little more alive.

The security guard grabbed the fish, sprinted for the elevator and shot up to the second floor to deposit it in the tide pool

61

Where Fresh and Salt Water Meet

Leaving the seashore diorama, the visitor moves along another corridor depicting the ecology of river estuaries — the complex interactions of plants and animals and water. The main focus here is a striking diorama of the Fraser River Delta. Among the birds featured in this diorama are Snow Geese. Their presence, as with many other birds in the scene, indicates that we are looking in on life on the Delta on a day in winter — at low tide. In winter, river deltas such as this, become "home" for birds that spend their summers far away from here. For example, the Snow Geese you see may go as far as the Soviet Union to nest on islands off the north coast of Siberia — the Green-winged Teals to northern British Columbia — the Gadwalls to Alberta — the Trumpeter Swans to Alaska — the Dunlins to the edge of the Beaufort Sea; the Great Blue Heron, on the other hand, might go no farther than Stanley Park in Vancouver.

A mural almost invariably stands apart from its foreground; a diorama backdrop does not

But it is the state of the tide, and what it reveals, that draws these birds to the Delta on this day in winter. At low tide, the aquatic plants and animals that provide food for these birds throughout the winter are exposed by the receding water. As we look in, they are busy harvesting this bounty.

This display, as with the seashore diorama, has a remarkable impact on the visitor because of the backdrop. An artist painting backdrops for dioramas faces a problem no other painter of large murals has. A mural almost invariably stands apart from its foreground; a diorama backdrop does not. The foreground of a diorama consists of simulated trees, or rocks, or sand, or buildings — or any other manifestation of man or nature — and because of this the artist's success depends largely upon integration of foreground with backdrop. This is known as the middle ground, an area over which the eye must move without any perceptible sense of change from three dimensions to two.

Artists work from photographs, roughing out a sketch on a pad to establish dimensions. Then the important thing is to get something, anything, down on the gaping white canvas. Painters quail at the first brush stroke, as writers do with the first word on a blank sheet of paper. After that, it is a question of solving a multitude of problems: problems of scale, of perspective, of verisimilitude and, most especially, of light. An exact re-creation of the light that exists at an actual scene will not necessarily work under

62

the artificial light of a museum. So in a sense the artist has to create a reality which doesn't exist.

Most people will agree that the artists in this museum have succeeded. One of them recalls going into the *Living Land, Living Sea* gallery one day to find a group of people sitting on stools in front of easels, painting the seashore diorama. He took it as a singular compliment.

So in a sense, the artist has to create a reality which doesn't exist

The End — For Now

The diorama of the Fraser River Delta ends this gallery, the first phase of the natural history exhibits. The next phase, now (1984) being created on the mezzanine above the Fraser River Delta, will tell more of the water story of British Columbia.

In this new phase, you will become part of the story by moving into, and through, many of the displays. For example, you will start by entering a glass-walled elevator that will take you from the darkness of the depths of the *Open Ocean* — where you will glimpse the strange forms of life adapted to live under such conditions — through the mid-levels where light-producing fish are found, to water near the surface, water rich in life.

In this new phase, you will become part of the story by moving into, and through, many of the displays

Also, by another elevator — this one built to resemble the interior of a submarine — you will descend into the relatively protected *Coastal Waters* where, via a series of "underwater cabins" you will pass through a display of the sea creatures that live in these waters.

Leaving *Coastal Waters* and, incidentally, the world of salt water, you enter the microscopic, underwater world of a *Fresh-water Pond* where models of invertebrate animals stare balefully from the green water.

While phase two of our natural history exhibits is about water, and the things that live in water, and while you will be spending a lot of time "under" water, there is no water involved; it will all be an illusion.

Still on the drawing boards is the third phase of our natural history exhibits. In it we hope to introduce you to other forms of life — terrestrial life — such as life in the dry interior of the province, in the alpine areas, and in the boreal forest. We have no doubt that these displays will be as exciting, entertaining and educational as all that has come before them.

More
Museum

More Museum

So far, we have looked only at the three permanent galleries in the exhibits building. There is much more to be seen, both in and around this building.

Thunderbird Park

For example, on the northeast corner of the Museum complex, there is Thunderbird Park, a park created in 1940 to display one of the Northwest Coast Indians' principal artforms, the totem pole. Totem poles, by virtue of sheer size, and by the seemingly grotesque imagery of the carvings, have always caught the attention of white people. Their purpose was heraldic; they carried the inherited crests and stories of individuals belonging to the nobility of a band or group of bands. They might be erected as house-posts, or placed in front of a house. They might celebrate a living member of the nobility, or commemorate the death of one — or they might be mortuary poles, containing the remains of the deceased.

From a museum's point of view, the problem with totem poles is that many of them are so tall — some as much as 24 metres — that they must be displayed in the open. But this in turn leads to a second problem: preservation. The poles are invariably carved from Red Cedar and even though cedar is admirably resistant to decay, a century is probably the limit of practical endurance in the open air.

Thunderbird Park was one of the last accomplishments of Francis Kermode before his retirement, after 36 years, first as Curator, and finally as Director, of the Museum. Yet, in 1952, only 12 years after the Park was created, it became obvious that the original poles, many dating back to the last century, would be destroyed by decay if left in the open for many more years. Consequently, a decision was made to bring in skilled Indian carvers to produce exact replicas of the best of the old poles and, after replacing them in the Park, to store the originals under cover.

This was an inspired solution because it also served to revive a dying artform. Indian carvers now work in full public view in the carving shed, a replica of a Haida 'big house'. This, in itself, is an educational experience for the public, who are free to ask ques-

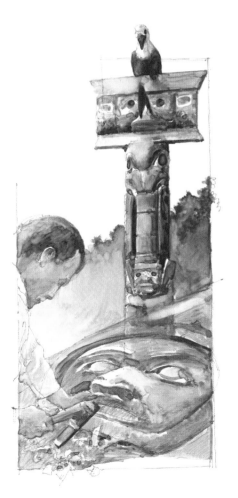

Indian carvers now work in full public view in the carving shed, a replica of a Haida 'big house'

tions about materials, tools and techniques of the carvers as they work.

Another addition to Thunderbird Park was the Kwakiutl 'big house' of Mungo Martin. The houseposts bear some of the hereditary crests of his family. This house, too, is a duplicate, a copy of a house built at Fort Rupert about a century ago by a chief, Naka'penkim, whose position and name Mungo Martin had inherited and assumed. Although the original house in Fort Rupert was twice as large, its style of construction and the carvings on the houseposts have been faithfully reproduced. There is, in fact, another 'big house' in the *First Peoples* exhibit inside the exhibits building but it was not feasible to conduct ceremonies in the gallery — one couldn't light fires, for example, and the dancing and music would be distracting to visitors in other galleries. The one in Thunderbird Park, on the other hand, was entirely suitable. The potlach dedicating the building lasted for three days!

The Thunderbird from which the Park takes its name is, in the words of the late Wilson Duff, a former Curator of Ethnology at the Museum:

> *a powerful and awesome creature of Indian mythology. Thunder was thought to be the flapping of its wings. Lightning, according to some tribes, was the flashing of its eyes. According to others, it was its belt, the Lightning Snake, with which it harpooned whales to carry back to its home in the mountain-tops to devour. The Thunderbird was a common crest used on totem poles.*

Helmcken House

Behind Thunderbird Park is a building that is a historic artifact in its own right — Helmcken House. A little over 130 years ago, a narrow country lane traversed the site of the Museum complex from east to west. Later, the lane was elevated to the suburban respectability of a street — Elliot Street — and the first two houses on it belonged to two of British Columbia's most distinguished citizens: Dr. John Sebastian Helmcken and Sir James Douglas. Douglas' home has long since disappeared. The house built by Helmcken in 1852 remains on its original site beside the exhibits building and is now maintained by the Heritage Conservation Branch of the provincial government.

Helmcken was a physician trained at St. Guy's Hospital in London. He arrived at Fort Victoria in April, 1850. Victoria was merely a staging post; his intended destination was Fort Vancouver, on the Columbia River, where he was to take up an appointment as staff surgeon for the Hudson's Bay Company. In fact, he never did get to the Columbia; the Hudson's Bay Company was forced by the influx of American settlers to relinquish the post and Helmcken remained in Victoria as surgeon to the Fort.

When he arrived, Vancouver Island had just become a colony, with Richard Blanshard as its first governor. Blanshard's health was poor; he soon resigned and was succeeded by James Douglas. In 1852, Helmcken married Douglas' eldest daughter, Cecilia, and went on to become Speaker of the first Legislative Assembly, a position he held while Vancouver Island remained a colony separate from the mainland. He spent the rest of his long life in Victoria, dying in 1920, in his ninety-sixth year. The culmination of his political career came when he served on a three-man commission, headed by Joseph Trutch, sent to Ottawa to negotiate the terms of Confederation in 1870. After that, he retired from politics and followed his calling as a doctor.

He arrived at Fort Victoria in April, 1850

Built to his own design shortly after he was married, Helmcken's original three-roomed house is the most easterly single-storey section of the building. Families in those days grew almost as fast as the years and two additions, clearly marked in the building's outline, were added in quick succession.

In his published reminiscences, Helmcken describes the exigencies of house building in the middle of the nineteenth century:

> *Mr. Douglas gave me an acre of land, wanted me to live on it, there would be mutual aid in case of trouble at any time from Indians — besides there were no servants save Indians — and they never remained long and would not live in houses. I ought never to have built there, and soon found it very inconvenient away from my office in the fort. The piece of land was very rough and cost a good deal of time and money to clean, this being done by Indians from the North.*

> *The timber had to be taken from the forest, squared there and brought down by water. When brought to the beach [now the Inner Harbour], I had big oxen of the Company haul it to the site.*

69

Lumber very scarce and a favour to get any at forty dollars per thousand in the rough — so it all had to be planed and grooved by hand. Kanakas [Hawaiian Islanders] cut most of it in a saw pit so it was not very regular in thickness. I wrote to Blenkinsop at Fort Rupert for plank — he sent me some and also some yellow cedar, from which the doors, windows and skirting boards were made.

The expense and annoyance was very great.

But, for Victoria, in 1852, it was snug, perhaps even luxurious, and many of Helmcken's possessions have been retained.

By current standards, the house was small. The fact that people were shorter even a 130 years ago than they are now seems evident in the low ceilings and doorways, and the height of the door knobs. Although the timber is remarkably well preserved, it looks somewhat rough-and-ready; the floors have none of the sanded uniformity of modern ones. The fireplaces were minute and they must have needed constant stoking in the winter. But, for Victoria, in 1852, it was snug, perhaps even luxurious, and many of Helmcken's possessions have been retained. One can easily imagine the Doctor stepping across to confer with his father-in-law about matters of state before being called out to slosh through the mud to some patient's sick bed.

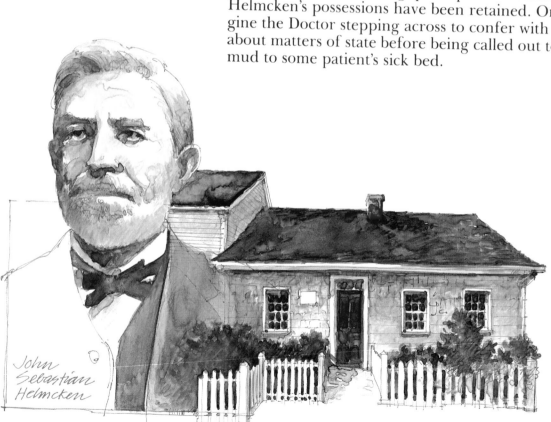

John Sebastian Helmcken

St. Ann's Schoolhouse

Immediately opposite Helmcken House, separated by a small courtyard, is another historic building: St. Ann's Schoolhouse. And, whereas Helmcken House is almost certainly the oldest residential building remaining in Victoria, St. Ann's Schoolhouse is almost certainly the oldest building of any description to survive.

In the 1850s, Modeste Demers, recently appointed as the first Roman Catholic Bishop of Vancouver Island, sought help from the Church to set up a school. Victoria, with its fort, was still a frontier settlement and the problem of education was an urgent one. After a number of discouraging rebuffs, Bishop Demers finally found help in the diocese of St. Jacques de l'Achigan, in Quebec. Four nuns and a lay assistant were dispatched on the long journey by ship down the Atlantic coast, across the Isthmus of Panama by train and then up the Pacific Coast to San Francisco and, eventually Victoria, to found a school.

The journey took two months. Sisters Mary of the Sacred Heart, Mary Angele, Mary Luminar, Mary Conception and lay assistant Mary Mainville stepped ashore in Victoria from the *Seabird* on June 5, 1858, the year in which the Fraser River gold rush brought its dramatic influx of miners to Victoria.

In preparation, Bishop Demers had purchased a log cabin to serve as a convent. That cabin was the nucleus of what eventually became known as St. Ann's School. Nine metres long by six wide, it was built in 1843 (the year Fort Victoria was constructed) and had been occupied since then by a French Canadian employee of the Hudson's Bay Company and his Indian wife. It came on the market when the wife died of consumption. The price was $500. The Bishop paid $100, the remainder to be paid when the school began to generate revenue.

In a letter, Sister Angele described conditions when the nuns took possession of the 'convent':

His Lordship had left orders for the house to be put in a fit condition for the reception of the sisters. This precaution had not been attended to, so we found the place just as it had been left after the funeral of the poor woman — bed unmade, floor littered with medicine bottles, basin, etc. and window panes cracked or broken. We hung our aprons for window blinds.

Victoria, with its fort, was still a frontier settlement and the problem of education was an urgent one.

Bishop Demers

71

Undaunted, the energetic sisters set about putting their house in order. There were, apparently, some tasks the sisters themselves could not perform and these were allocated to Mary Mainville, the lay assistant. One was to paint the picket fence surrounding the property. While doing this, she received no less than ten proposals of marriage — many of them pursued with such ardour that she was finally forced to leave the task unfinished and retreat into the convent.

It is difficult to establish just when the building actually opened as a school. Some reports claim it was on June 7, 1858, but it seems unlikely that the nuns could have started teaching only two days after they stepped ashore in Victoria. In any event, when classes began, the furnishings were obviously spartan. Seats consisted of rough boards placed on packing cases. Tables were made of the same rough boards set on trestles. A portable blackboard, slates, slate pencils and 'readers' provided by the nuns completed the equipment and furnishings. Here, the sisters worked and lived; and their duties were not confined to teaching. They were expected to nurse the sick and care for the dying, as well as saw their own firewood, clear the land and cultivate their garden.

Seats consisted of rough boards placed on packing cases

Classes began with 35 pupils, two of whom were non-paying orphans. There were three sessions in the school year. The fees were $60 a session for boarders, $11.25 for day scholars. The curriculum included "Reading, Writing, Arithmetic, practical and rational Bookkeeping, Geography, Grammar, Rhetoric, History, Natural History, English, French, plain and ornamental Needle and Net Work in all their different shapes" If teaching did begin as early as suggested, they must have started with day scholars; the boarders could not have been accommodated until after an extension had been added.

The school was an immediate success. The original class of 35 increased rapidly so that, only five months later, the building had to be enlarged to twice its original size. This must have been a relief to the sisters, who no longer had to cook and eat their meals, and sleep, in a little room partitioned from the classroom.

St. Ann's Schoolhouse was moved from its initial site on Heywood Avenue to the Museum grounds in 1974. Since then, it has served not only as a historical artifact in its own right but as a

classroom in which contemporary pupils can experience the atmosphere (and the discomforts) of a pioneer schoolhouse in the middle of the nineteenth century.

The school was an immediate success. The original class of 35 increased rapidly so that, only five months later, the building had to be enlarged to twice its original size

St. Ann's School Graduating class 1888

The original St. Ann's schoolhouse

73

The Native Plant Garden

S o far, we have looked only at structures and artifacts, at buildings and totem poles. But there are other things to look at. For example, unless it is pointed out to them, few visitors seem to realize that the landscaping around the Museum complex is, in fact, a living extension of the indoor natural history exhibits; it is a *Native Plant Garden*. Unlike a conventional, formal garden, displaying nursery-grown aliens, the *Native Plant Garden* is unique because it presents plants native to British Columbia in habitats as close to their natural ones as can be re-created.

As a result, the Garden provides a valuable research and teaching facility. Botany students use the Garden to practise their taxonomy, nature photographers and artists enjoy the advantage of using live subjects without having to travel long distances to find them, and school children learn how the Indians used the plants for food and medicine.

The Garden, like the natural history exhibits, is divided into habitats such as sand dune, forest shade, rocky alpine, dry slope. As each plant is collected it is catalogued, and detailed information of who collected it, and where it was collected, is recorded; thus the growing conditions under which it was found can be reproduced. A label identifies the plant with both its common and scientific names when it is planted in the Garden.

As a final focus of interest, the fossilized footprints of a long-extinct dinosaur, found near Hudson Hope on the Peace River, reminds us once again, like a photograph of a historic building now demolished, that nature is constantly changing.

. . . The Garden provides a valuable research and teaching facility

Salal (*Gaultheria shallon*)

74

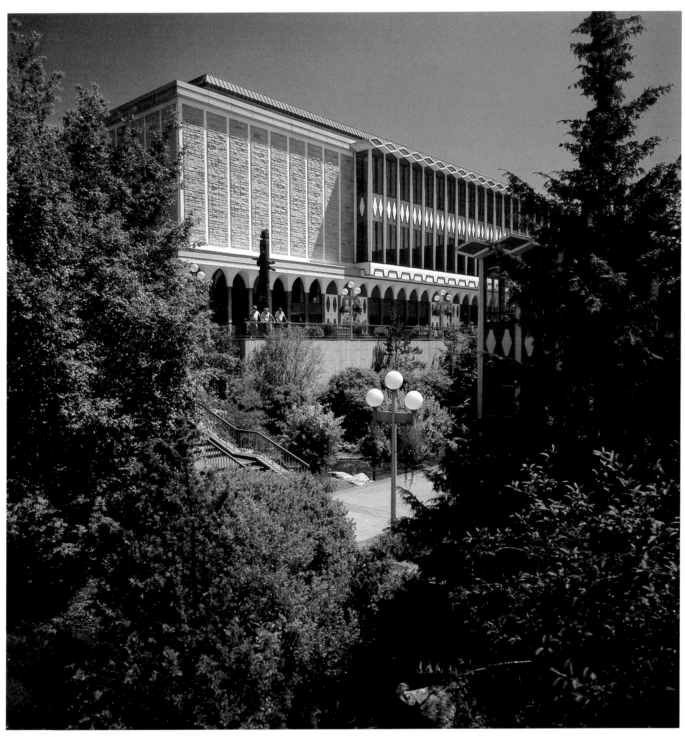

Native Plant Garden

75

The Rain Curtain

N ow let's take a last look in the exhibits building to see what we might have missed on our first visit. As you enter through the handcarved wooden doors into the main foyer, you are greeted by a symbol of the climate of British Columbia. Here, the rain curtain, tall and glistening, dominates the atmosphere. Long after one has examined the dramatic cedar carving of a Nootka whaling scene, the relief map of British Columbia and the totem poles, one turns again to the sight and sound of the rain curtain. At its base are ferns, the plants that dominate much of the floor of any coastal rain forest. Above is a bank of lights, constantly changing colours to represent the moods of the coast — colours ranging from silvery-white to smoky amber.

For those who like to know how things work, the system of water circulation is really quite simple. Water is pumped from a 3,400-litre fibreglass tank in the basement, up the six-metre plastic tubes that form the curtain. The water is then allowed to trickle down the outside of the tubes, thus creating the rain image.

Oddly enough, there seems to be no record of whose idea it was to use a rain curtain as an introduction to the Museum, but this marriage of technology and art has produced a visual image as dynamic and vibrant as the coast itself.

Administration and Education

L eading from the foyer — to your right as you enter — are two parallel corridors. The first one leads to the Administration offices. Here, the support functions of a large and complex organization are performed. Budgets have to be allocated, bills have to be paid, personnel records have to be maintained, and all these normally burdensome things have to be accomplished without stifling the creativity of an institution as diverse, subtle and complex as this museum.

The Administration and, of course, the entire Museum, has to take its lead from the Director and the Assistant Director. Both have to have a firm grasp of every discipline if they are to make wise decisions when it comes to allocating budgets, to encouraging

76

one venture or discouraging another. The Directorate has a heavy responsibility but, by the same token, the rewards are considerable. Few museum directors in the world preside over such a dynamic and successful one.

The, second, far, corridor leads to the Education and Extension Division. This division radiates information generated by the Museum to schools, community museums and the public in general throughout the province.

An extensive schedule of school programs is offered to all age levels, either by classes or in family programs which are attended by the parents as well. These programs usually consist of a tour through part of the galleries, followed by a classroom session. Although the staff teach some of them, the majority are taught by 'docents'. In simple terms, a docent is a person who has been professionally trained and who offers his or her services voluntarily. There are approximately 130 docents on strength. They undergo rigorous training each fall, with a refresher in the spring. As a result, each year upwards of 50,000 school children and adults receive in-depth experiences with the collections that, since many of the artifacts used are replicas of the originals, can be handled as well as looked at. Reservations must be made for all tours but trained volunteers are on hand in the galleries to give spot talks and answer questions. In addition, special programs are offered to school groups around the province.

Many young scholars write to us after a program to comment on the experience. "Dear Dosent, I throughly enjoyed the toor. Thank you for letting us see the thing," said one. Another was more specific. "Dear Docant, I liked the egg that roaled araund and wouldent full off a clif or sommthig." Yet another, the sort of critic we appreciate, wrote to say: "Who ever put that museum together is the smartest people I know."

The Extension services are composed principally of a program of travelling exhibits, circulated to community museums both within the province and nationally, and a program of speaker's tours. These programs make it possible for the Museum to circulate part of its collections for the benefit of the whole province — and indeed to other provinces as well. They are funded by the federal government and add an extra and significant dimension to the Museum.

"Who ever put that museum together is the smartest people I know."

Apart from Administration and the Education and Extension Division, there is one more area the visitor needs to know about on the ground floor. It is an auditorium with seating for 530 people, situated at the south end of the exhibits building, and named after another distinguished Victoria physician, Dr. Charles Frederick Newcombe, and his son, William.

Charles Newcombe, like Helmcken, received his training in Britain. He arrived in Victoria with his wife and five children in 1889. By 1892, he had become increasingly involved in his botanical and geological collections which, until then, had been merely a hobby. After a brief and unsuccessful attempt to return to his first interest, 'alienism' (the treatment of the mentally disturbed), he embarked on a new career. He became a collector on commission to George Dawson, of the Geological Survey of Canada, and to Franz Boaz of the American Museum of Natural History in New York — and eventually for the British Columbia Provincial Museum.

Newcombe's hope had been to hold a salaried position and pursue his collector's career as an amateur. But the salaried jobs evaded him and he had to make a business of his collecting. His eldest son, William, although still well short of a formal education, joined him as an active partner and eventually became an authority in his own right.

In 1924, shortly after a collecting trip to the Queen Charlotte Islands, Newcombe died. During his career, he had been instrumental in shipping totem poles from the west coast to Kew Gardens, Chicago, New York, the Smithsonian Institution in Washington, D.C., Edinburgh, Sydney, Melbourne, Bremen, as well as Ottawa and Toronto. Whatever the merits of these activities, two things were obvious: Charles Newcombe did not make very much money from his collecting; and, without him, the British Columbia Provincial Museum would have a far less comprehensive collection of Westcoast Indian art than it has now.

The auditorium named after him has, over the years, provided a rich variety of programs

The auditorium named after him has, over the years, provided a rich variety of programs, ranging from university credit courses to folk singers; from musical plays about the life of Emily Carr (an internationally known Victoria artist of the early 1900s) to academic lectures on scientific subjects. Funded by the Friends of the

Provincial Museum, 'the Newcombe' reaches out to the public with a mixture of education and entertainment.

These are some of the more salient features of the Museum — it would take a book much longer than this one to describe them all — but there is one more building, perhaps the most important of all, that we must look at before we finish our story — the Curatorial Tower.

The Curatorial Tower

Behind
the
Scenes

Behind the Scenes

'The Tower'

It comes as a surprise to many people to learn that the public displays are quite literally the tip of the iceberg in almost any museum. The truth is, they represent only a small proportion of the total collections, only a small reflection of staff activities. The real hub of *this* museum is the curatorial 'Tower', located to the west of the exhibits building. It houses not only the curators with their technical staffs but the laboratories with their sophisticated equipment — equipment that makes it possible to analyze and learn a great deal about everything that comes their way. From there, lines of communication radiate, not only to the Museum complex, but to the community at large.

It is there, too, that the bulk of the collections reside and the collections are the public treasure trove, things rare or unusual, some just meaningful, and all priceless as present and future heritage information — and sometimes valuable in dollars too. The 'Tower' holds over a million objects in collections, and about ninety specialized people including staff, visiting scholars, volunteers, and others.

The Collections

Collecting things seems to be an almost instinctive human urge. Most museums came into being when the state, or some other organization, accepted stewardship of an individual's private collection. These were usually called collections of antiquities, of natural history specimens or herbariums. In every case, once accepted for the benefit of the general public, the collections took on an importance of their own — an importance that few people, we suspect, paused to analyze.

Nowadays, most people would agree that museum collections have recreational, cultural and educational value. But other, very real values, scientific and practical ones, are often overlooked. At this stage, there is a temptation to offer a carefully reasoned justification for museum collections. Instead, we are going to cite some examples of the benefits they offer and leave readers to judge for themselves whether or not they have value.

Why, for our first example, bother to collect and preserve specimens of small and obscure insects, as the entomologists do; insects so tiny and esoteric that few of us ever see them? The answer is that, small and insignificant as these creatures may seem to us, they play a vital role in the environment; a role which, if ignored, can lead to serious consequences.

More specifically, we have progressed to a stage where, if a large, man-made development, such as an oil pipeline or an open-pit coal mine, is being contemplated, it must be preceded by an environmental impact study. Biologists who set out to do this study cannot be expected to be specialists in every discipline in biology; thus it is unlikely that they will recognize 'our' insect when they encounter it. This is when the collection, and its specialist custodian, the curator, comes into the picture. He can identify the insect by comparing it with specimens in the collection; he can relate its life history and its behavioural characteristics — whether or not it is a predator, whether or not it is a parasite, what plants it "damages."

In this case, it transpires that our little insect is a predator. It feeds on the larvae of, and thus keeps in check, a species of caterpillar which has a voracious appetite for the indigenous vegetation. Damage to the habitat of our "insignificant" insect, the disruption of its life cycle, would result in a sudden explosion in the population of the caterpiller — and a consequent devastation of the vegetation in the area. But it is the vegetation in the area that controls erosion, that prevents the avalanches and mud slides capable of rupturing the pipeline or wiping out the workings of the coal mine.

In short, this small and obscure insect, because it has been collected and studied by the Museum, moves through education to science and, finally, to economics. It does not sit in isolation, an object collected merely for the sake of collecting.

For another example: The Parks Branch plans to build a camp ground on the edge of a park, with a tarmac parking lot beside it; but they have discovered some objects which look as though they might be human artifacts in the area they chose for the parking lot. They come to the Museum for advice. Both the ethnologists and the archaeologists in the Museum are able to recognize the artifacts because they have similar ones in their collections. They know why the artifacts were there. They identify the proposed

It does not sit in isolation, an object collected merely for the sake of collecting

84

parking lot as a former Indian burial site. Had the plan been implemented, there could have been serious social consequences. The Indian Band concerned would regard the parking lot as a desecration of an ancestral burial site.

The list of practical applications is virtually inexhaustible. A dairy farmer whose cattle are sick brings in a plant to learn if it might be the culprit. A rancher who is thinking of moving to a bigger ranch in another part of the province brings in samples of grass to find out if they will provide good grazing. A fisherman calls to describe unusual fish in his nets. He is told they are there because of El Niño, a warm Pacific current that has moved unusually far north carrying them with it. A forester arrives with an insect he suspects may be the cause of the damage he has observed among the Yellow Cedar in the extensive logging operation he supervises. A researcher asks for historical information about an Indian Band; information that may eventually be used in negotiations to settle an Indian lands claim. A curator answers the telephone at home at two o'clock in the morning. The caller, a doctor in the hospital, describes the berries of a plant which were eaten by his patient. The curator identifies the plant, and the doctor knows what he is dealing with now; he will look up the antidote for the poisonous berries. The list goes on and on.

Of course, there are some collections in universities that can serve a similar purpose. But they tend to lack continuity. As a rule they depend on the interests of an individual faculty member. When that faculty member leaves to take up another post, or retires, the collection is often broken up and dispersed or simply decays because of neglect. In contrast, the Museum, by an act of the Legislature, must maintain its collections, not for the benefit of the Museum but for the continuing benefit of the public.

In more strictly scientific terms, the collections constitute an archives, not only of human records but of natural ones as well. The herbarium of the botanists contains dried specimens of some plants that succumbed to urban expansion; they are now extinct in that area. The zoological collections contain specimens of creatures that have suffered the same fate: the Dawson Caribou, once peculiar to the Queen Charlotte Islands, for example.

Why keep them, then? That is like asking why people are fascinated by the fossilized bones of an extinct dinosaur. It is because they tell us something about the past. They may offer evidence,

The Museum, by an act of the Legislature, must maintain its collections, not for the benefit of the Museum but for the continuing benefit of the public

notwithstanding the objections of creationists, of evolutionary changes. We may learn in Darwin's terms that they were not the fittest (which does not mean the strongest or most cunning; it means the most adaptable) creatures, so they did not survive. Or we may learn that a vast geological or climatic disaster caused their extinction. Or, with creatures who have more recently become extinct, we may simply discover that they were destroyed as a result of our carelessness; we failed to protect their environment.

But quite apart from these more tangible benefits, collections are fun; they provide recreation. Few people can avoid the fascination of examining a 4000-year-old stone arrowhead, or the carved wooden halibut hooks used by Indian fishermen, or the curious devices the early European settlers used to churn butter or pluck chickens. As we have said, only a small proportion of the collections can be put on public display, but anyone with a special interest can, by making arrangements beforehand, seek out the collections in the 'Tower' and examine some of the million objects and specimens stored there. Somebody who works with the collections and knows a great deal about them can provide useful information and indicate where to find more. A new enthusiasm may be kindled; a new article or book may be born. These collections are our heritage and should be our joy — as they certainly are to the curators.

The Curator

The stereotyped image the word 'curator' evokes is usually one of dust and decay; of dry, academic fastidiousness; of a person jealously protective of something simply because it is old. The reality is remarkably different. The reality is a group of archaeologists leaping into the water to drag an inflatable boat through the pounding surf on the west coast of Vancouver Island, where they will locate and map a former village once occupied by more than 200 Nootkan Indians. Or of a botanist climbing out of a helicopter onto a mountain ledge to search for rare alpine plants. Or of a historian descending into the long-abandoned (and thus extremely dangerous) workings of a mine to inspect the material evidence there to discover which of the stories he has heard about the mine are true. Or of an aquatic zoologist, crouched in the

nose of a submersible 650 metres beneath the surface of an inlet, hoping to see creatures no one has ever seen before.

The dictionary definition of a curator is, "person in charge, manager; custodian of a museum." And, of course, they do do a lot of managing. No museum can collect everything that is offered, so collections policies have to be worked out. Budgets have to be administered, research plans formulated; people's creativity has to be channeled towards common goals. In fact, there are eight curatorial divisions, each (excepting one, a single-curator division) with its own small hierarchy. There is the curator who, in addition to his or her research activities, manages the division. There is an associate curator, who in addition to his or her research, has to find time to help with the administration too. And there are, depending on the size of the division, a number of assistant curators and technicians. The technicans provide support, perhaps with photography, perhaps with maintenance of scientific equipment, or perhaps with the preparation of artifacts or specimens, either for the study collections or for public display.

As well, curators are responsible not only for collections and research, but for passing on their knowledge to other scientists in their fields and to the general public. They have to write articles and books, both academic and popular; they have to give lectures and demonstrations, slide presentations and interpretations. They are, to use a current buzzword, the principal 'interface' between the Museum and the outside world.

Let's look at some of their activities, just a few, because these activities are so extensive and diverse that we can only touch on them here.

On the sixth floor of the 'Tower', a curator of archaeology, more specifically a paleoecologist, is bent over a microscope examining grains of pollen. He collected these grains in the Fraser Valley by drilling for a core into the bed of a swampy lake; the sediment in the core contained them. To do this, he had first to design a raft, a sort of minuscule drill rig, assembled from lengths of timber, together with metal brackets, sheets of plywood and eight large blocks of hard styrofoam for flotation. Taken altogether, this is an awkward assemblage, even before it has been bolted together, to carry through the bush. But the knowledge gained by its use is incentive enough for the curator and his colleagues; they have carried it on their backs over many, many kilo-

As well, curators are responsible not only for collections and research, but for passing on their knowledge to other scientists in their fields and to the general public

metres of rock, through countless dense thickets of willow and Salal, to reach a desired bog or swamp.

He will discover that the pollen grains he is examining now are 1,200 years old. They have been preserved because the properties of the sediment and moisture reduce the supply of oxygen, thus retarding decay. By their shape and structure, he can identify the species of plant which shed them; their age can be determined by radiocarbon dating. As a result, he and his colleagues will have a picture of the plants and trees, and some indication of the climate, that prevailed in the area more than a thousand years ago. This, in turn, casts light on the human history of the area at that time.

But archaeologists can serve the present as well as the past. In 1984, the body of a young woman was found in a park less than a kilometre from the Museum. The body lay in a thicket of Ocean-spray and was lightly covered with soil and plant debris. The police did not know whether it had been placed there recently, and then covered with soil, or if it had been there long enough for the natural accumulation of soil and debris. They asked the Museum for help.

The paleoecologist knew that, unlike the pollen in the bed of a swampy lake, pollen on a soil surface degrades rapidly; thus, any pollen he found would be no more than a year old. He also knew, from records kept for the *Native Plant Garden*, that, in 1984, Oceanspray flowered, and shed pollen, between June 6 and June 24, almost six months before the body was found. By taking samples of the pollen in the soil on top of the body, and comparing them with samples from below it, he learned that there was 16 times the amount of pollen on top. The ground surrounding the body had been disturbed; the ground beneath it was undisturbed. Consequently, he established that the body was probably placed there after June 6 but well before June 24, and that a thin layer of soil had been scooped onto the body from the surrounding area. Given this time frame, the police were quickly able to identify the body and verify from other evidence the archaeologist's dates.

In an office two doors away is another archaeologist. He, too, is bent over a microscope, examining stains on a sliver of obsidian. Several years ago he became interested in how the stone projectile points used on heads of arrows or spears by our predecessors were made. He set about teaching himself how to make them, using the same materials available to the original toolmakers. Just

as he had mastered this difficult art, he read an article by an English archaeologist who claimed that tools became polished by use and, by examining the quality of the polish on a chert or flint tool, one could determine whether it had been used to cut meat, wood or bone — or any material for that matter.

The curator tested this theory by replicating stone tools and using them; but he couldn't convince himself that there was any abrasive medium in wet leather or meat, and not much in green wood, for example. So he went back to examining actual tools, obsidian micro-blades which, when spliced into a wooden handle, made superb knives for skinning and butchering an animal, and which he himself had recovered from an archaeological site on the British Columbia-Yukon border.

In place of the 'polish', he found an organic material on them that had clearly been deposited when the tools were used. He found tissue, fragments of feather, hair and red blood cells, all clearly visible under a high-power microscope; this material was bound and protected by a layer of blood. He learned that, if a thin smear of blood dries rapidly, and there is enough ultra-violet light around during the drying period, the stain will last for tens of thousands of years. Eventually — and we are skipping over years of painstaking research — he discovered a way to identify the species of animal whose blood was shed by the tool more than 4000 years ago. By growing minute crystals of haemoglobin from the blood, he found that the crystals of each species are different. Consequently, once an ancient village or camp site that yields stone tools has been found, we can now tell from this blood-on-stone what animals there were in the area and something about the diet of our predecessors. One more piece in the jig-saw puzzle of our prehistoric past has slipped quietly into place.

Eventually . . . he discovered a way to identify the species of animal whose blood was shed by the tool more than 4000 years ago

On the floor below, the associate curator of Modern History is reviewing his notes. He has just returned from a field trip to Ocean Falls, an abandoned pulp and paper mill on the coast, some 500 kilometres northwest of Vancouver. The town was named after the spectacular waterfalls from Link Lake. It was one of the first of the instant company towns and, as such, provides a superb microcosm, both of a society and of an industrial development.

Ocean Falls, then an abandoned Indian village, was chosen as the site for a pulp mill in 1912 because the raw material, trees,

were readily available and so was the water to create a dam and generate electrical power. In 1917, the mill was upgraded to manufacture paper from the pulp it generated. For more than 50 years the mill supported a town of up to 4000 people; then problems reared up. The mill was becoming obsolete, uncompetitive. Large sums of money were required to modernize it; but the modernization would also mean a substantial increase in the amount of electrical power required to operate the mill. The existing dam and power plant was incapable of supplying it and there was insufficient water flow to allow an expansion; to bring in power from another source on a grid line would be prohibitively expensive. Reluctantly, the company decided to close down.

The social consequences were obvious: without the mill, Ocean Falls must inevitably become a ghost town. Virtually the entire population would be out of work. For several years the provincial government kept it going. In the end, they, too, reluctantly decided to close it. Now it was sitting there, an untouched archive. The records of the first machinery installations are still there — even the records of the first oil changes and bearing replacements. Altogether, there are more than 20,000 plans, 200 linear feet of company and municipal records. And there is continuity. It's all there, a curator's dream.

In an adjoining office, an assistant curator has just completed a study of the patterns and fashions of clothing in the nineteenth century. Now he is thinking of embarking on a study of the evolution of work clothes and safety devices in the mining industry. Starting with soft leather boots, a cloth cap to keep dust out of hair, and what was called a 'Sticking Tom' — a candlestick with a spike that miners drove into a timber to give light while they worked — he will progress through carbide lamps, steel-toed boots to hard hats and battery-powered lamps. The clothing will be more difficult. While plenty of examples of high fashion, of frock coats and wedding dresses, have survived, few people bothered to keep examples of their work clothes. He will have to dig for this information if we are to know where we came from in this context.

Up at the very top of the 'Tower', on the seventh floor, a curator is listening to a tape recording of an old man speaking in Squamish, a language that is now almost extinct — only a handful of old people still speak it. She is transcribing what she hears onto paper in a mixture of letters and symbols that only linguists can

translate. This is because many of the native Indian languages possess sounds never used in other languages. And, since the Indians had no written language, linguists have had to invent an alphabet to describe these sounds.

For the same reason, the lack of a written record, the history of the Indian peoples had to be passed down from generation to generation by word of mouth. On this tape, the old man is retelling some of the history of his people, the songs and the myths.

As we observed earlier, when the first Europeans arrived here, they tended to regard the Indians as savages. That was because they could not interpret their behaviour — their songs, dances and ceremonies — all of which seemed as irrational and incomprehensible as the Christian doctrine must have seemed to the Indians when they first encountered it. Now, as a result of the work of many people like this linguist, we are coming more and more to appreciate the depth, the complexity and the sophistication of the cultures that existed before the coming of the white man.

Now, as a result of the work of many people like this linguist, we are coming more and more to appreciate the depth, the complexity and the sophistication of the cultures that existed before the coming of the white man

Three floors below, vertebrate zoologists are at work. An assistant curator is just putting the finishing touches to a paper, prepared in collaboration with a colleague, on a very rare specimen that came their way. Its scientific name is *Kogia simus*, a Dwarf Sperm Whale that normally remains in tropical waters and has never previously been sighted in Canadian waters.

The whale, which is only 2.3 metres long, was first spotted by park wardens at Pachena Bay, in Pacific Rim National Park, on the west coast of Vancouver Island. It had beached itself. It was stranded at high tide in a pool of bloody water. No external injuries were evident. The park wardens called in biologists from the Bamfield Marine Station, who returned the whale to the sea. It promptly beached itself again. A second rescue attempt seemed to be successful; the cetacean swam out to sea.

However, the following morning it was found again, dead this time. By now the Museum had been notified and zoologists hurried to Pachena Bay to recover the carcass. After photographing it, they transported it back to Victoria. There a series of measurements were taken and an autopsy performed by a physician who works as a volunteer with the zoologists. They could not establish the cause of death, but found evidence of a recently aborted fetus. The phenomenon of whales that appear to deliberately beach themselves is still unexplained; only a layman would risk suggesting that in this case it might have something to do with the loss of her offspring.

The phenomenon of whales that appear to deliberately beach themselves is still unexplained . . .

Dwarf Sperm Whale (Kogia simus)

Among other things, the zoologists learned from the stomach contents that the whale's diet, recently at any rate, had been a mixture of squid and shrimp and, from a cross-section of a tooth — which has growth rings — that she was at least 12 years old. After that, the flesh was removed and her skeleton joined the bone collection in the 'Tower'.

The same curator has recently acquired another rare specimen — though not so rare as the Dwarf Sperm Whale — a Vancouver Island Marmot. Strictly speaking this is not an endangered species, but estimates are that the total population is only about 200. For this reason, of course, curators have not trapped any for their own collection. It would be some sort of an ultimate irony if they were to contribute to the extinction of a species merely for the sake of possessing a specimen. This one was brought to the Museum by a hiker who had found it the previous day. An x-ray revealed the cause of death. It had been killed with a shotgun.

After the measurements were recorded, the Marmot was skinned, the hide was prepared as a study specimen; the bones went into the collection and the curator, who is conducting research into the Vancouver Island Marmot, learned a good deal that would have had to be speculation but for this specimen.

The curator of the division has been engaged for some time in research of bird sounds and songs. Although most of us would like to believe, as the poets would have us, that a Skylark sings for the sheer joy of living, the reasons for bird sounds and songs are much more complex — too complex to be dealt with here. One practical advantage, though, to emerge from this research, is that when a 'voice print' of a bird sound is made, it becomes an admirable tool for identifying that bird. Some birds, although they belong to different species, are so similar they are extremely difficult to identify visually. But a 'voice print' of the sounds they make is instantly recognizable as such, even though it varies from one individual to another.

. . . The curator . . . learned a good deal that would have had to be speculation but for this specimen

Black-legged Kittiwake (Rissa tridactyla) and voice printer

On the first floor of the 'Tower', there are no curators; instead there are conservators (not to be confused with conservationists). Conservators are responsible, not only for the preservation of the collections, but also for the consolidation, cleaning, repairing, storing and preparing for transport, of all manner of artifacts and specimens — everything from an airplane to a silver ornament excavated after lying for half a century in the ground; everything from a Woolly Mammoth to a mosquito. And, because virtually every artifact in a museum has suffered from some form of deterioration, the conservator is in some ways comparable to a physician. He or she has to diagnose the kind of deterioration and then provide the most effective treatment to cure the ailment. In an increasingly contaminated environment — the air is almost invariably full of industrial pollutants; buildings contain more and more chemical substitutes for organic building materials — this exercise requires a high level of scientific expertise.

In addition, there are problems of consolidation. For example, the artifacts recovered from a 'wet site', unless they are effectively treated on the spot, will promptly decompose when they are exposed to air. The question of light, artificial or natural, has to be dealt with. Artifacts on display have to be seen, of course, but too much light can cause fading of colours and general deterioration of organic materials (ultra-violet rays, which exist both in fluorescent light and in sunlight, are particularly dangerous). Thus a compromise has to be found. Simple cleaning poses another problem. Too much cleaning can destroy the patina, which may contain evidence of an artifact's age and history; too little can conceal the detail and thus fail to reveal the skill of the artist or craftsman who created it. Or, as with the archaeologist's micro-blades, the all-important bloodstains might be removed. Once again, a compromise has to be found.

The evidence that the Museum's conservators have been successful in finding these compromises lies, not only in public view in the galleries, but lurks in every corner of the 'Tower', where the major portion of the collections reside.

On the first floor, too, taxidermists from Vertebrate Zoology practise their art. Recently, they learned of a new process, one that significantly reduces the amount of time and labour required to prepare a specimen. The process is freeze-drying and, thanks to the Friends of the Provincial Museum, the taxidermists have a brand new freeze-drying chamber. They are still experimenting with it, but initial results with both birds and mammals up to the size of coyote have been gratifyingly successful. The trick, if the specimen is for display, is to make sure it is in a natural attitude. Once frozen, not even the smallest change can be made.

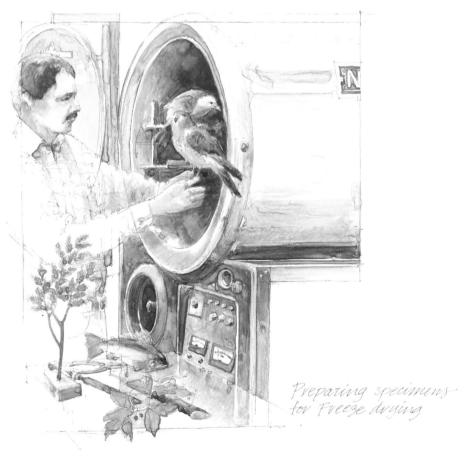

Preparing specimens for freeze drying

In the Ethnology Division, the curator has just put the 'phone down. He is enjoying a glow of satisfaction. The call was from the Director, informing him that the 'Friends' have approved his request for funds to purchase a set of 17 Kwakiutl masks representing animals from the woods. Apart from the fact that these masks are valuable because, in the words of an art critic, they demonstrate the baroque detail and complexity of the Kwakiutl carvers, the curator is elated because two of them, carved in the 1940s, represent the later work of Willie Seaweed, one of the most gifted of Kwakiutl artists. Another gap in the collection has been filled.

Another gap in the collections has been filled

A few doors away, a technician sits at a single-bar loom. She is practising the techniques used by the Chilkat weavers to produce their superbly beautiful ceremonial blankets. The techniques required to weave the circles and curves in the designs used by this culture are perhaps as difficult and complex as in any hand-weaving in the world. The technician needs to know about these things, not only as a simple matter of understanding, but also so that she can assess the potential value of any Chilkat blankets the Museum may want to acquire.

They found one species that had never been collected in the province before . . .

On the second floor, the curator of botany is settling back at his desk. He has just returned from a private home where he had to identify the house plants. He was asked to go there by the family doctor. A child in the household had fallen ill. The doctor had been unable to diagnose the illness. He wondered if perhaps the child had been tempted to sample the house plants. The curator was able to assure him that none of the plants, if eaten, would cause more than temporary discomfort. The doctor had to look elsewhere for his diagnosis.

Now the curator is putting together the results of the most recent collecting trip he made with one of his assistants. They visited the mountains in the Flathead area, in the southeast corner of the province — an area where virtually no botanical collecting had been done. They found one species that had never been collected in the province before, Dwarf Cliffbrake (*Pellaea pumila*), a tiny fern growing in limestone crevices, as well as a number of relatively rare alpine plants. Like the curator of Ethnology, the botanist is elated because another gap in the collections has been filled.

One is inclined to think of botanical collecting as a placid rather than an adventurous occupation; yet here, as in other field trips,

unexpected dangers lurk. The curator recalls an earlier trip with his assistant. They had been told by a naturalist that there was a stand of Garry Oaks in the Fraser Valley. At the time, it was thought that this tree's Canadian range was confined to southern Vancouver Island, so they set off to investigate.

To reach the reported stand, they had to cross the Fraser River from Yale by boat and then walk along the Canadian National Railways track. This seemed simple enough, but they came to a tunnel and that gave them pause. Fortunately, a track mainten- ance crew was at work nearby, and they learned from the crew that the tunnel was more than a half a kilometre long, but they would have plenty of time to get through; the next train wouldn't come by for nearly an hour. Emerging from the far end of the tunnel, they had to follow the track for some distance before climbing to a knoll on which the trees were growing. They were, indeed, Garry Oaks, and the botanists set about measuring them; then they drilled holes into some of them with an increment borer, a device that extracts a core without damaging the tree. The core reveals the annual growth rings and thus establishes the age of the tree. As they worked, they heard the train rumble past on the track below.

After they had finished examining the stand, and recording all the associated trees and plants in the area, they set off to return to the boat. It was only when they reached the tunnel again that the thought occurred to them; they should have made more compre- hensive inquiries about train movements. They paused to deliber- ate. Somewhat sheepishly, the curator knelt to put his ear to one of the rails. Finally, they decided the only thing was to make a run for it. They bolted through the tunnel, anxiously speculating about whether it would be wiser to lie down between the rails, or try to flatten themselves against a side wall if they encountered a train.

A minute or two later, they burst from the tunnel, eyes wide, chests heaving. Turning in surprise, the maintenance crew hur- ried towards them to find out what was wrong. When the main- tenance crew understood the problem they began, rather unkind- ly, to laugh. Evidently, the next train wasn't due for another four hours.

Before leaving the second floor, we should look at one other small but important group of people who work there: the Library

staff. Since the beginning, books and magazines have been purchased for research and reference by virtually all the Museum's staff. These materials are now found in the various divisions of the Museum in loosely organized libraries. There are over 20,000 books and over 200 magazine subscriptions. Some of these books were purchased or received as gifts in the 1880s and are of considerable value. The majority, however, have been acquired more recently. The Library staff operate a centralized order and information service, often conducting computer searches of other libraries to provide research information. They also deal with incoming requests for information from other libraries, museums and the general public.

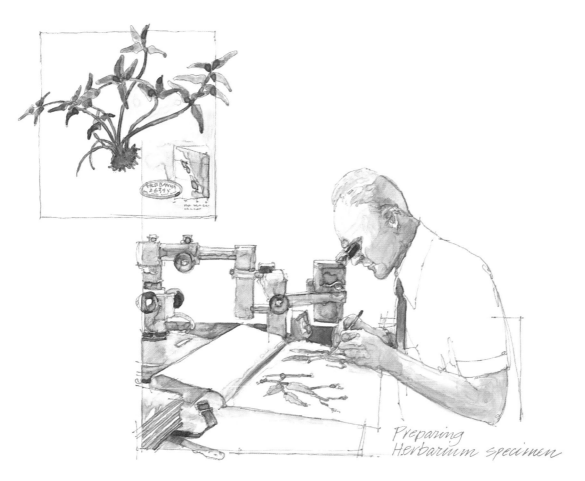

Preparing
Herbarium specimen

Also, working in an office with the Library staff, is the Editor. His task is to ensure that all written material published by the Museum maintains a high standard of literacy and that it is comprehensible to the audience for whom it is intended.

By and large, this is a thankless task. Most people tend to regard their own writing as immortal prose; they resent, sometimes vehemently, any suggestions for changes. Recognizing this, the Editor has a cartoon pinned on a board beside his desk. In it, a person is working on a cross-word puzzle. "What," he asks his companion, "is a word for 'vile and loathsome reptile'? I tried 'Editor' but there are too many letters."

Two floors above, a technician is editing 16 mm movie film. An experienced SCUBA diver, he is also a prizewinning underwater photographer. He has some graphic, and rather gruesome sequences, including one of a sea star attacking and devouring an abalone, and another of a ling cod, darting from behind a rock to seize a small fish — sequences that may be used in the forthcoming *Open Ocean* display.

The curator of his division is sitting at his desk. He has just put down the 'phone. His caller had described a fish he had caught off one of the local breakwaters and asked what it was. Based on an inadequate description, the curator had given a tentative identification. The next question was a familiar one: "Is it good to eat?" The curator could only tell him that, as far as he knew, it wasn't poisonous.

In general, this curator's interests lie in a different direction. While the so-called sports and commercial species have been intensively studied by government fisheries biologists, and biologists in privately-funded marine research centres — the salmon and trout, the herring and grayling, the halibut and the bass of the rivers, lakes and coastal waters — little attention has been given to what might be called the 'non-consumer' fish; creatures that might prove to be of crucial importance in their environments. It is here that the Museum comes in. The curator is not confined to the study of the immediately economic. Indeed, he is likely to become more excited about a tiny, luminescent fish found only at great depths than about a 30-kilogram Spring Salmon.

At the moment, he is reviewing research he has conducted on and off for several years into the way in which fish communicate

The curator is not confined to the study of the immediately economic

with one another. People know a good deal about how dolphins and whales communicate, but not much about how fish do. He still has a long way to go. There is light, of course. In really deep water, where there is very little ambient light, some fish have luminous attachments to lure prey; others use sudden flashes of light to confuse their attackers. There is colour; fish respond to pigment, particularly in mating rituals. By implanting false pigment, he once enticed male fish to attempt the act with each other. There is considerable evidence that vibrations emanating from swim bladders are used to communicate, but there is still much work to be done. Another obvious means of communication is by movement; but here, too, there are problems. The seemingly instantaneous changes of direction from one end of a large school of fish to the other, for instance? — though this may have something to do with underwater sound or odours.

The 'phone rings again. The curator deals with a question about sea urchins which, since it became known that they are a delicacy to the Japanese, have become a marketable item. He puts the 'phone down and glances at his watch. He is due at a meeting in ten minutes. He turns to his research notes again. A new avenue of speculation is beginning to open up; an avenue that can be investigated empirically. The problem is to find the time.

In the room adjoining his office — a large room filled with shelves which, in turn, are filled with glass jars containing specimens preserved in alcohol — a technician is topping up some of the jars. One specimen has a peculiarly undershot jaw. He holds the jar up to the light, wondering why the peculiarity evolved. As he lowers it, the jar slips from his fingers, shatters on the floor and the technician utters a scatological expletive.

The curator agrees, but it doesn't help much.

And lastly, sharing the fourth floor with the aquatic zoologists, is the Museum's lone curator of entomology. For the past four years he has been studying a parasite of a parasite. Working with a Canadian Wildlife Service biologist at a wildlife sanctuary at Qualicum, on the east coast of Vancouver Island, he has been studying the nests of swallows. There are some old barns in the sanctuary and, appropriately, Barn Swallows build their nests in them.

The curator discovered, early in his investigation, that a type of blowfly lays its eggs on the nestlings just after they are hatched.

When the eggs turn into larvae, they suck blood from the nestlings. The mortality rate caused by these parasites accounts for 80% of the deaths among the nestling Barn Swallows.

Next, he discovered that after the blowfly larvae have drunk their fill of young swallow blood, they pupate; a hard shell forms around them. Now a second parasite appears; a wasp no larger than a pin head. The wasp seeks out the blowfly pupa, inserts its tiny oviposter through the hard shell and lays its eggs — eggs which hatch into larvae that eat, and kill, the pupa.

The investigation is still in its early stages, but the fascinating interaction between these three creatures is emerging. Barn Swallows feed on insects, which in turn feed on vegetation. If the parasite wasp is exterminated, presumably there would be a proliferation of blowflies, the swallows would be exterminated, and the insects they normally keep in check would play havoc with the vegetation. But if the blowfly were exterminated, the swallows would proliferate and exterminate the insects they normally feed on. What then? Well, of course, we don't know yet; we don't know what part all those other insects the Barn Swallows feed on play in the overall scheme of things. And, in any case, cause and effect are seldom so simple in nature. But we hope to find out eventually. It won't be in this decade, probably not in this century, but eventually we shall need to know if we are to avoid contributing to our own extinction.

These are a few examples of the activities pursued in the 'Tower', just a small sampling, but enough, perhaps, to indicate that a museum is more than a repository for dusty artifacts and moth-eaten specimens; and enough, perhaps, to indicate why the 'Tower' is the centre of the little universe we call the British Columbia Provincial Museum.

A museum is more than a repository for dusty artifacts and moth-eaten specimens

102

The Crystal Ball

So much for the past and the present. Now what of the future? If present trends continue, collections-related research will rapidly advance the state of knowledge about museum collections. This exciting information to be revealed in the next decade or two will be translated into exhibits and publications.

The technology of exhibitry is beginning to make changes in a way that may indicate future directions. Undoubtedly computer technology will assist visitors in accessing the vast amounts of information available in a museum. Experimentation with interactive computer terminals is already underway in many museums. The re-creation of complete environments — old street scenes, full-scale forests, etc. — will continue with the visitor becoming part of the exhibit, not just an observer on the outside of the glass. New methods of artifact and specimen protection will result in the visitor being able to get in closer contact with precious museum objects.

The programs that emanate from museums will become an important part of community life. Museum visitors are becoming increasingly better educated and curious about the world around them. There seems to be the beginnings of a move for museums to provide films, speakers and dramatic performances on subjects related to their collections. In the future, programming in museums will become one of the focuses of a community's social activity.

As ever, this museum will be on the forefront of these new ideas and changes. The philosophy that carried this museum from its modest beginnings to its present status is embodied in the statement, 'anything is possible'. With that philosophy as our guide, the future of this museum will be exciting and inspiring for both the Museum staff and you, the visitor.

If present trends continue, collections-related research will rapidly advance the state of knowledge about museum collections

A Short History of the British Columbia Provincial Museum – 1886-1968

1886 The Museum came into being as a result of a petition, signed by 30 prominent citizens. The petition was presented to the Lieutenant-Governor, C. F. Cornwall. He forwarded it, with a recommendation for approval, to the Executive Council who, in turn, approved it.

John Fannin was appointed as the first curator. Fannin had come to British Columbia from Ontario as a young man. He had worked as a ranch-hand in the Okanagan, and as a miner in the Big Bend and Cassiar districts, before settling in the Hastings area of Vancouver to make his living as a shoemaker. He was, at the same time, an outdoorsman, a collector and a gifted taxidermist.

John Fannin

The new institution opened in a room adjoining the Provincial Secretary's office in the Capital Buildings, commonly known as the 'Bird Cages'. For some curious reason the legislation formalizing the status of the Museum was not enacted until 1913. Fannin contributed 12 cases of his own mounted mammals and birds to the collections.

1889 The Museum was moved into the former Supreme Court Building.

1898 A second move was made to the East Wing of the present, then newly-constructed, Legislative Buildings.

1904 John Fannin retired. Francis Kermode, Assistant Curator, was chosen to replace him.

At this time there were four people on staff:

Francis Kermode, Curator
Ernest M. Anderson, Assistant Curator
Walter Behnsen, Second Assistant
Samuel Whittaker, Janitor and Attendant

Total Budget (including salaries) $5,556

1911 Registered attendance (actual attendance was probably two to three times these figures) increased from 3,740 in 1889 to nearly 30,000 by 1911.

1913 The *Provincial Museum Act* was proclaimed, giving the Museum formal operating authority and defining the objectives as follows:

a) to secure and preserve specimens illustrating the natural history of the Province

b) to collect anthropological material relating to the aboriginal races of the Province

c) to obtain information respecting the natural sciences, relating particularly to the natural history of the Province, and diffuse knowledge regarding the same.

1915 President Theodore Roosevelt of the United States visited the Museum and was photographed on the steps with Premier McBride and Francis Kermode.

1916 Wartime measures called for strictest economy, so only two field trips were carried out.

1918 An entomologist, Mr. E. H. Blackmore, joined the staff.

1921 The basement of the East Wing was excavated and turned into exhibition space, making it possible to bring out ethnological specimens from storage to be put on display.

1928 William Newcombe joined the staff as Assistant Curator of Biology.

1932 William Newcombe was terminated on grounds of economy.

1934 Dr. Ian McTaggart Cowan was appointed Assistant Curator of Biology.

1936 Museum staffing levels finally regained the mark reached in 1914 (six, including security guards), when wartime restraint had been imposed.

1939 The first in the series of Occasional Papers was published: *The Vertebrate Fauna of the Peace River District of British Columbia,* by Ian McTaggart Cowan.

1940 Dr. Ian McTaggart Cowan resigned to accept a position at the University of British Columbia.

Francis Kermode retired after more than 40 years with the Museum. Dr. G. Clifford Carl was appointed Acting Director.

1941 Thunderbird Park was officially opened.

1944 The Curatorial staff consisted of the Director, a botanist, an entomologist and an anthropologist.

1945 Attendance was estimated at 75,000 (a record year to date).

1952 The totem pole carving program in Thunderbird Park started.

1961 Estimated attendance reached 100,000 (64,000 registered).

1962 The Provincial Museum of Natural History and Anthropology 75th Anniversary Banquet was held at the Empress Hotel on Saturday, October 27.

1963 Premier W. A. C. Bennett announced plans to construct a new Museum and Archives building as a Centennial project.

1964 Museum attendance was estimated at 160,000

1967 Another *Provincial Museum Act* was passed, recognizing the need for a division to study and preserve artifacts from the period of European settlement in the province.

1968 The Provincial Museum of Natural History and Anthropology was renamed The British Columbia Provincial Museum.

Francis Kermode

Image Credits

Photographers:

Grant Hollands
pp. 16 left, 19, 21, 32, 37, 51, 55, 59, 60, 75, 79

Rob D'Estrube
pp. 16 right, 23

Andrew Neimann
p. 42

Sources:

The Provincial Archives of British Columbia

The Royal Ontario Museum

Washington State University

British Columbia Provincial Museum